Impressions of Wenceslaus Hollar

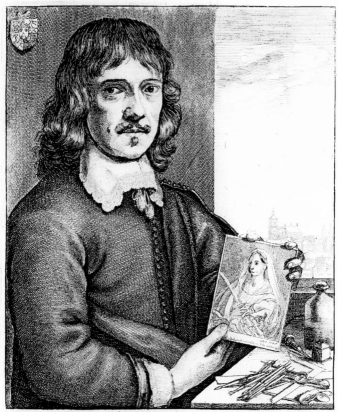

WENCESLAUS HOLLAR

Gentilhomme ne a Prage l'an 1607. a esté de nature fort inclin p.^r l'art de meniature principa=
lement pour esclaircir, mais beaucoup retardé par son pere, l'an 1627. il est party de Prage aijant
demeuré en divers lieux en Allemaigne, il c est addonne pour peu de temps a esclaircir et apliquer
l'eau forte, estant party de Coloigne avec le Comte d'Arondel vers Vienne et d'illec par Prage
vers l'Angleterre, ou aijant esté serviteur domesticque du Duc de Iorck, il s'est retire de la a cause
de la guerre a Anvers ou il reside encores.

Ie. Meyssens pinxit et excudit.

Impressions of Wenceslaus Hollar

Rachel Doggett, Julie L. Biggs, Carol Brobeck

The Folger Shakespeare Library
Washington, D. C. 1996

Distributed by University of Washington Press
Seattle and London

This volume has been published
in conjunction with the exhibition
Impressions of Wenceslaus Hollar,
presented at the Folger Shakespeare
Library, Washington, D. C., from
September 25, 1996 through
February 3, 1997.

The exhibition and the catalogue were
funded by The Winton and Carolyn
Blount Exhibitions Endowment and
The Andrew W. Mellon Publications
Fund of the Folger Library.

Distributed by
University of Washington Press,
Seattle and London.
ISBN 0–295–97594–6

Photographs by Julie Ainsworth.
Details and photomicrographs by
Julie L. Biggs.

Cover illustration:
The Fleets Off Deal, 1640 (P548).

Deal was Hollar's port of entry into
England in 1636. His etching records an
event that occurred there three years later,
in September 1639, when a Spanish armada
took refuge from a Dutch fleet in English
waters. While King Charles sought to
betray the Spanish to the French, the Dutch
attacked and scattered the Spanish ships.
The legend on the far right of the etching
lists the fleet to which each of the numerous
ships belonged.

Frontispiece:
Wenceslaus Hollar (P1419).

Hollar etched his own portrait after a
painting by J. Meyssens. In his hands he
holds a copperplate of Saint Catherine of
Alexandria (P177) after a Raphael painting
that was in the Arundel collection and is
now lost.

Table of Contents

Foreword

Wenceslaus Hollar was among the most cosmopolitan artists of early modern Europe. Born in Prague in 1607, he spent most of his life in England, with a prolonged stay in the Low Countries. Like his great predecessors Dürer and Holbein, and his more eminent contemporaries Van Dyck and Poussin, Hollar worked his way across several countries, spreading delight and wonder at his extraordinary gifts. Though notable for drawings and watercolors, Hollar is remembered today for his vast and varied production of etchings. These achieved wide circulation in his own time and have attracted a devoted following of connoisseurs and collectors ever since.

Hollar's appeal, as this exhibition amply demonstrates, rests on more than one foundation. A master of precise and detailed renderings, Hollar at his best fuses technical virtuosity of a high order with telling observations of topography, urban life, social behavior, material culture, and style in architecture, transportation, technology, and dress. His art affords immense pleasure, while opening wide, clear vistas on his broad experience as a close observer of seventeenth-century life. In his youth a protégé of the Earl of Arundel and in later life a free-lance artist working for a variety of printers, publishers, and patrons, Hollar depicted an immense variety of subjects. Portraits of grandees and elegant women; flora and fauna; ships; landscapes; beheadings; cathedrals; topographical views—all these are the stuff of Hollar's penetrating gaze. Because of his role as both artist and witness, and especially because Hollar spent so much of his forty-year career portraying England and the English for themselves, the Folger Library has been collecting his work for a long time. Recent acquisitions have brought our holdings to about 1400 examples, about half of Hollar's known *oeuvre*. Although we lack a number of his major works, ours constitutes one of the world's important collections of this artist; and as one might expect, the Folger's resources shed particular light on Hollar's work as an illustrator of books. Consequently, the curators of this exhibition have brought to light several interesting examples of Hollar's work which had not previously been recognized. At the same time, the authors of this cata-

logue have benefited greatly from the rich scholarship—some of it quite recent—devoted to Hollar and his times.

The exhibition presents 150 examples—just over ten percent of the Folger's collection. The task of selecting and organizing these works, and then writing the case labels, catalogue entries, and the interpretive essay published here, fell to three talented members of the Library's staff. Rachel Doggett, Andrew W. Mellon Curator of Books and Exhibitions, brought her learning and deep knowledge of the Folger's collections to the effort, and coordinated many aspects of a complex collaborative enterprise. Julie Biggs, Senior Paper Conservator in the Library's Patterson Conservation Laboratory, shared her knowledge of printmaking techniques and studied the materials with a keen eye for detail gained through years of experience handling and treating works of art on paper. Carol Brobeck, Program Coordinator in the Library's Folger Institute, was granted a sabbatical leave to pursue her research and writing for the exhibition and developed special expertise on Hollar's topographical images. Without the individual and collaborative efforts of this team, neither exhibition nor catalogue could have seen the light of day (even

in its softened and filtered version in the exhibition gallery).

As always, the Library's conservators, led by Chief Conservator J. Franklin Mowery, designed and implemented the installation and prepared the artifacts for exhibition. The Department of Photography, and in particular its Head, Julie Ainsworth, undertook the difficult assignment of photographing Hollar's art for this catalogue.

In these times, the publication of a scholarly catalogue devoted to the graphic work of an early artist whose name is hardly a household word is an expensive—even risky—undertaking. The Library extends its gratitude to Winton M. Blount and Carolyn Blount, whose vision and generosity have helped to support both the exhibition and the publication of this catalogue. We welcome this opportunity to express our appreciation once again to the Andrew W. Mellon Foundation for its assistance—through the Mellon Publications Endowment here at the Library—to the Folger's ongoing efforts to produce works of scholarship which cannot be counted on to pay their own way.

I hope that this exhibition will open many eyes to the fascination of European civilization in the time just after Shakespeare

lived, and to the power, brilliance, and charm of one of its most interesting and prolific artists.

Werner Gundersheimer
Director

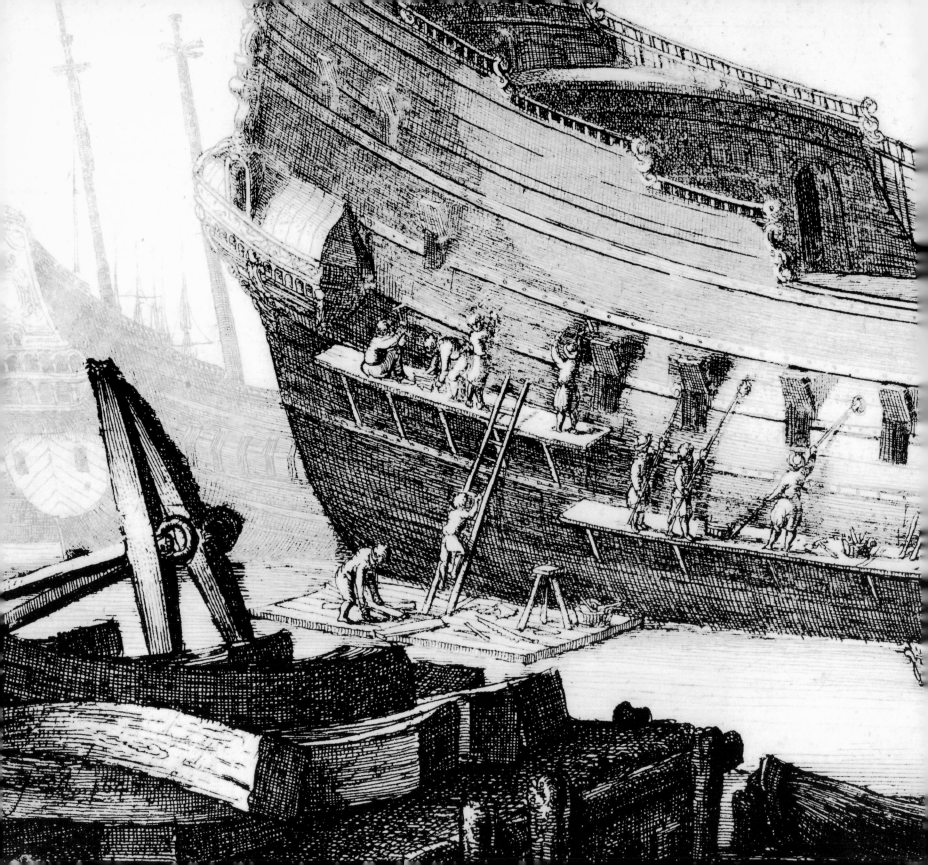

Impressions of Wenceslaus Hollar

The etchings of Wenceslaus Hollar—his architectural and topographical views, his maps, and his depictions of people, fashions, and events—have done more to shape our ideas of seventeenth-century English life than the work of any other artist. His etchings after artworks in the Arundel collection and his plates of buildings such as St. Paul's are invaluable records of artifacts and edifices that in many cases no longer exist. His views of European cities, of large expanses compressed into tiny spaces, his dazzling studies of women's costume, and his vivid depictions of crowds of people impress us with their virtuosity and clarity of detail. Strangely, we know relatively little about Wenceslaus Hollar, the man who created these images, beyond short references to him by John Aubrey and John Evelyn and in the correspondence and diaries of some of his other contemporaries.[1] His etchings and drawings reveal occasional glimpses of the man who made them but add little to our knowledge of his life.

Impressions of Wenceslaus Hollar is about Hollar's impressions of the world in which he lived, how he saw that world, what captured his attention, his affection, and his imagination, and what he was commissioned to see and record. It also examines his technique—how he transferred his impressions to paper, how he conveyed the delicate pattern in a piece of lace, the richness and warmth of a fur muff, the soaring grandeur of a great cathedral, or the play of light in a candlelit room. In addition, *Impressions of Wenceslaus Hollar* reflects *our* impressions, our responses to the artist who was nearsighted and used "a glasse to helpe his sight," yet etched such delicate lines that often we need a magnifying glass to see them; the talented copyist, who could reproduce another artist's work and record a landscape or building, but could not quite master the contours of a human face; the man who was captivated by lace and fur, by texture and lines, and yet eschewed baroque exaggeration in favor of simplicity and clarity. Finally, this exhibition is about our impressions of Wenceslaus Hollar's world as he interpreted it, a world that was unsettled by

Opposite: Detail of Fitting Out a Hull (P1264).
See catalogue no. 103.

Wenceslaus Hollar's self-portrait with his father's arms underneath, 1647 (P1420).

century since his death there has been a major publication devoted to listing and classifying his etchings: George Vertue's *A Description of the Works* (1745 and 1759), Gustav Parthey's *Wenzel Hollar: Beschreibendes Verzeichniss seiner Kupferstiche* (1853), and Richard Pennington's *A Descriptive Catalogue* (1982). Parthey listed over 2,700 etchings either signed by or attributed to Hollar. Pennington maintained Parthey's numbering and classification, but he questioned and clarified numerous entries while adding others; his *Descriptive Catalogue* is the most comprehensive and authoritative listing of Hollar's etched work.*

Of the more than 2,700 etchings by Wenceslaus Hollar, nearly 1,400 may be found in the collection of the Folger Shakespeare Library in at least one state. Not all are here in the first state by any means, but many are here in more than one state or in multiple copies. The 150 etchings in this exhibition have been chosen to represent aspects of Hollar's entire career, from his travels in Germany in the 1630s, through his years in England, in Antwerp, and in England again, until his death in 1677. They represent both the most celebrated and the most obscure examples of this remarkable artist's work.

What we know of Wenceslaus Hollar's

life also has been carefully recorded by Richard Pennington and others.[2] We have made no attempt to compile a biographical essay, but we have tried to provide what is essential for understanding Hollar's artistic development, the context in which he worked, and the etchings on display.

The Road from Prague

Wenceslaus Hollar was born in Prague on July 23, 1607. There the Holy Roman Emperor, Rudolf II, had surrounded himself with many eminent painters, sculptors, scientists, and philosophers. Prague was an exciting city for a boy with artistic leanings, and, while he may not have had access to Rudolf's celebrated collection, Hollar must have visited printsellers' stalls and artists' studios at an early age. He apparently took great delight in drawing maps even as a young schoolboy. His father did not encourage his artistic ambitions, however, and by the age of twenty Hollar was ready to leave Prague. His decision to leave may have been influenced by the imposition of Catholicism in Bohemia following the Battle of the White Mountain in 1620. Although evidence for the nature of Hollar's religious upbringing is inconclusive, both John Aubrey and John Evelyn state that he was raised a Protestant.[3]

religious, political, and military strife, in which buildings and institutions crumbled, but in which Hollar saw great beauty nevertheless. It was a world that Hollar perceived with the eyes of a miniaturist and that even in his largest works he conveyed to us in minute detail.

Wenceslaus Hollar's work has been remarkably well documented. In each

Throughout this catalogue we have used Pennington numbers to identify Hollar's etchings. For a discussion of the techniques of etching and engraving, see page 59.

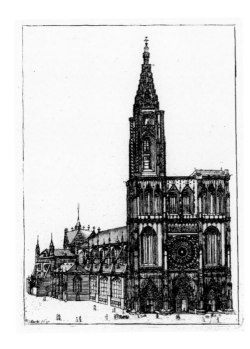

Hollar's family did not encourage him, but there are early works that indicate Hollar had received some training in the art of etching before leaving Prague, possibly from Aegidius Sadeler, who had been appointed imperial printmaker by Rudolf.[4] It may be that Hollar also began to develop his distinctive style of lettering in the Sadeler workshop. For Hollar, lettering was an integral part of a design, and it seems that here, rather than in landscape, Sadeler's influence may be found.

The schoolboy who delighted in drawing maps grew into a young man who possessed a strong desire to depict his surroundings.[5] Topographical art, realistic representation of actual places, and idealized landscapes found in paintings of biblical subjects, were the two traditions in landscape art to which Hollar, along with many other Continental artists, was heir. Dürer's work was greatly admired at Rudolf's court, and Hollar's sensitivity to landscape may have begun with his exposure to Dürer's watercolor landscapes. Even during his years in Prague, he must also have been exposed to the Dutch and Flemish landscape paintings that would so influence him throughout his life.

After Hollar left Prague in 1627, his first major stop was in Stuttgart, where he stayed until 1629. Numerous artists, including Hollar's countryman Karel Screta, had gathered there under the patronage of the ducal court.[6] Hollar moved on to Strasbourg, living there for a year and traveling to other German towns. While in Strasbourg working for the publisher Jacob van der Heyden, Hollar discovered that simple landscapes were worthy subjects for which there was a market.[7]

Early in 1631, Hollar was in Frankfurt, where he spent part of a year in Matthaeus Merian's workshop perfecting his understanding of perspective. Next to Abraham Hogenberg in Cologne, Merian was perhaps the best-known German printer of views, especially bird's-eye views and maps. By 1634, if not earlier, Hollar was active in Cologne, occupying himself primarily with landscape and costume. He also traveled along the Rhine to Amsterdam where he first saw the sea and made his first etchings of it.[8]

The development of Hollar's etching skill is well illustrated in his two views of Strasbourg Cathedral (P893 and P892), the first dated 1630, and its successor 1645. The earlier image, etched while Hollar was in Strasbourg, hints at his assiduous talent for detail, although it is flawed and uneven. The three doorways and the rose window of the façade exhibit his highly finished style, but he failed to convey the correct perspective and foreshortening of the nave and transept, in spite of the conventional angle he chose to depict. Fifteen years later, during his fertile Antwerp period, the Cathedral became a soaring structure set in contextual space. Hollar had given it life and verisimilitude. There are buildings around it, stalls nearby, and

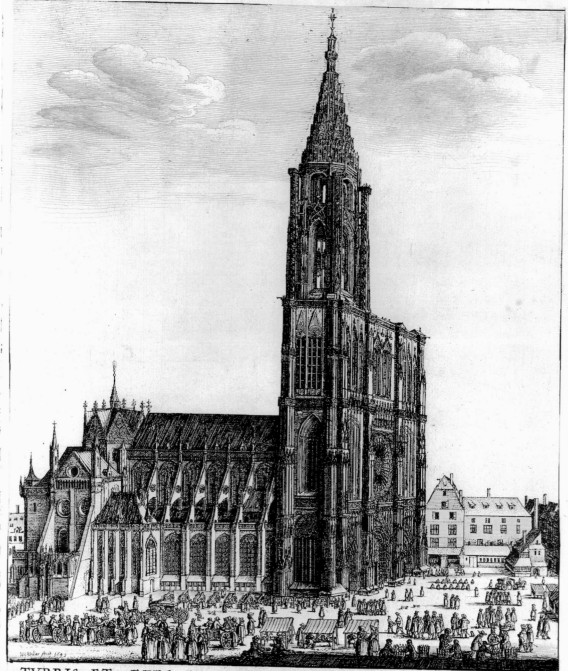

TVRRIS ET ÆDES ECCLESIÆ CATHEDRALIS ARGENTINENSIS.

à Wenceslao Hollar Bohemo, primo ad vivum delineata, et aqua forti æri insculpta, A: 1630. denuoq; facta Antuerpiæ, A: 1645.

groups of people walking, conversing, or engaged in their trade. Light was introduced; Hollar added sky, clouds, and shadows. Primarily, however, he had mastered a style and technique that at times has been criticized for its overabundant lines. It may not have universal appeal, but the sheer virtuosity of Hollar's method invites admiration.

England and the Arundel Circle

Probably the most important event in Hollar's life occurred in Cologne when, in May of 1636, the Earl of Arundel, renowned collector and patron of the arts, invited him to join the English diplomatic mission to the Emperor Ferdinand in Vienna. The embassy included a stop in Prague.[9] Although it is not clear just how Hollar made Arundel's acquaintance, it may well have been through the artist and art dealer Hendrik van der Borcht, whose son Hendrik had been engaged as curator of Arundel's art collection. Hollar recorded the journey of Arundel and his entourage in more than one hundred drawings and watercolors, most of which are still extant.[10] The young artist evidently made a favorable impression on Arundel, for at the end of 1636 he traveled to England to take up a position etching works in the Earl's and Countess's growing art collection. With

the rest of the Arundel party, he landed at Deal on December 27, 1636.[11]

During his early years in London, Hollar lived at Arundel House, located between the Strand and the Thames. Here and at Albury, their country house in Sussex, Arundel and his Countess brought together a large group of literati, artists, advisers, and agents.[12] Certainly Hollar and the young Van der Borcht would have been drawn into this circle. Arundel had opened his art collection not only to the connoisseurs who frequented Arundel House but also to other learned members of the public. His librarian, Franciscus Junius, praised his "Honourable Lord [who] out of his noble and art-cherishing minde, doth at this present expose these jewells of art to the publicke view in the Academie at Arundell house."[13] According to Vertue, Arundel intended that Hollar and Van der Borcht would draw and etch his artworks for publication, making them accessible to an even wider public.[14] It was Arundel's desire, apparently, to create with the etchings an enduring record of his collection, a "Paper Museum."[15]

For a few years, Hollar found himself in a very fortunate position. He not only had a generous patron and free access to one of the greatest of Renaissance art collections, he also was charged with a task for which

any young artist would have been grateful. Since it is unlikely that he had a close relationship with Arundel or that Arundel kept very tight control of his activities, Hollar was free to pursue work outside the Arundel collection. As an etcher working in London, he would have had little competition at this time as most intaglio printing was engraved.

Hollar's first important work in England was his long view of Greenwich (P977), etched on two plates and published in 1637. The work was remarkable for its long, fluid lines and for a harmony of water, sky, and land that would recur in numerous successive views. Hollar's transitions between foreground and background are so gradual that the artist suggests a vast depth of field. In the foreground, figures in motion lend vitality to the view and bring our eyes back toward the buildings in the middle distance. With *Grænwich*, Hollar brought to England a new approach to landscape; he influenced a tradition that had previously favored painted portraits and miniatures and that had valued landscape primarily as background.[16] The long view of Greenwich announced the presence of a new and distinctive talent in London and significantly affected the reception and practice of landscape art in England.

Long View of Greenwich, state 4, c.1644 (P977).

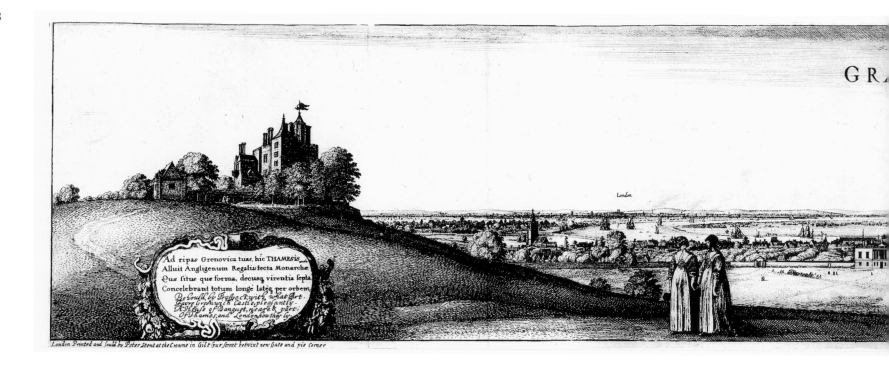

GR...

London

Ad ripas Grenovica tuas, hic THAMESIS
Alluit Angligenum Regalia tecta Monarchæ
Quæ situs quæ forma, decusq virentia septa
Concelebrant totum longe lateq per orbem.
Behould, by Prospective, what Art
Gaves Greenwich Castle pleasantly:
A House of Banquet, neare't part:
Of Thames, and London how they ly.

London Printed and sould by Peter Stent at the Crowne in Gilt Spur street betwixt new Gate and pie Corner

CH.

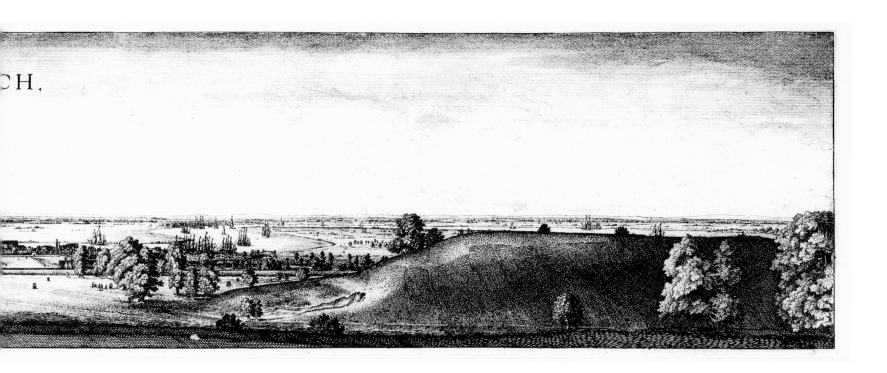

Hollar dedicated *Grænwich* to Queen Henrietta Maria, but he removed the dedication once her popularity declined, leaving the cartouche blank in the plate's second state. State three, from 1642 or 1643, was issued with four lines of Latin verse by Henry Peacham filling the space.

"Why Peacham," Pennington and others have wondered, "one of the most insignificant of minor writers?"[17] Peacham, perhaps, because he was there and because in Hollar he saw someone to whom he could be a mentor. In *Lord Arundel and His Circle,* David Howarth has confirmed Henry Peacham's presence in the group surrounding Arundel.[18] Peacham's inclusion initially may have have been due to his friendship with the architect and connoisseur Inigo Jones, but with the publication of his successful *Compleat Gentleman* in 1622, Peacham had earned his place in the Arundel circle. According to Howarth, Arundel encouraged Peacham to publish the work because it reflected many of Arundel's own beliefs about art and education. In fact, the volume was dedicated to William Howard, Arundel's son.

Peacham considered himself something of an authority on art. Like Hollar, as a boy he had shown a talent for drawing and painting but was discouraged by his father and teachers. In *The Compleat Gentleman,* he recounts being beaten by a schoolmaster for drawing and being told that he was to "bee made a scholler and not a painter."[19] Nevertheless, he published several works on art. In one of these, *The Art of Drawing with the Pen* (1606), which was incorporated into *The Compleat Gentleman,* he argued that a knowledge of art was necessary to anyone wishing to achieve the appearance of gentility.[20]

By the time Hollar arrived in England in 1636, Peacham had been reduced to working as a pamphleteer in London. He still had access to Arundel and to his collections, however, and it seems only natural that he would have sought out the young artists who had joined the Arundel household. It was during these same years that Hollar did his first work for London stationers. Peacham probably introduced Hollar to some of the city's printers and booksellers. Hollar's first work for the book trade was a frontispiece for Peacham's *The Valley of Varietie* in 1638. In the following year, he produced title pages and illustrations for two books by Jean Puget de La Serre. Both volumes were printed in London by John Raworth, son of Robert Raworth, who had printed Peacham's *Coach and Sedan* three years earlier.

It is hard to say whether Peacham had any influence over Hollar's choice of subjects or their treatment—he had devoted a chapter to landscape art in *The Art of Drawing*—but *Grænwich* must have had considerable appeal for the aging writer, for he apparently offered to provide verses for a reissue of the plate. Between 1637 and his death, Peacham supplied text for six of Hollar's etchings. Hollar would not need Peacham's introductions for much longer—the quality of his work was already being recognized—but Peacham must have been a valuable adviser during Hollar's first years in London. Peacham died in 1643 or 1644; it seems likely that in his final years he took on the role of mentor to a young artist who was finding his way in a new country, a young man in whom Peacham could see the embodiment of many of his own ideas and ambitions.

Fabric and Fur, Texture and Line

The title page that Hollar etched for John Johnson's *The Academy of Love* in 1641 (P2673) shares all the qualities of his costume plates. At the front of a crowded room, a young man and woman stand with Cupid between them. Both are fashionably dressed: she with a lace collar and a feather fan hanging from her waist, he with boots, spurs, and a hat. Despite the small scale of the image, Hollar draws our attention to the fine details, folds, and textures of the clothing.

Hollar's fascination with texture and his skill at reproducing it with his etching needle are among his most notable characteristics. It is intriguing to wonder whether the nearsightedness that Aubrey described and Hollar's use of "a glasse to helpe his sight" may have made Hollar particularly aware of the differences in the surfaces of things around him.[21] When viewing a tree through his glass, he would have been made suddenly aware of the roughness of the bark and the twisted lines of the roots. With his eyes, with a glass, or with the sensitive hands of an artist, he would have been equally aware of the lines and textures of fabric. His style of etching permitted him to record the tiniest details so that the softness and fluffiness of each strand of fur and the delicacy of a lace collar come through vividly in his finished plates. While Richard Godfrey is correct to call our attention to Hollar's "enraptured contemplation of the feminine world," it would be a mistake to overlook his equally rapt attention to the complexities of men's fashions, namely in the portraits of William of Orange, 1641 (P1522–P1524), and the Earl of Pembroke, 1642 (P1481).[22]

Hollar's interest in costume began early. Several of his plates of Continental fashions were published in Cologne in

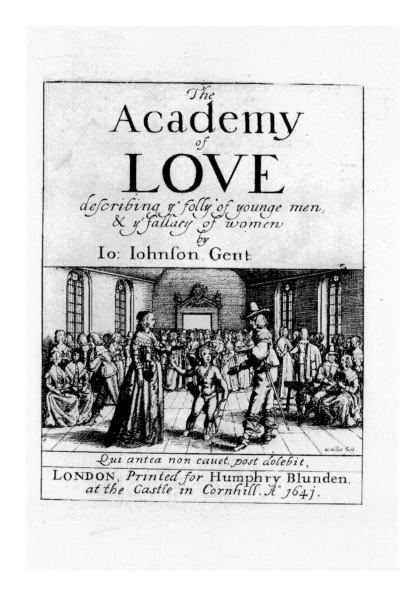

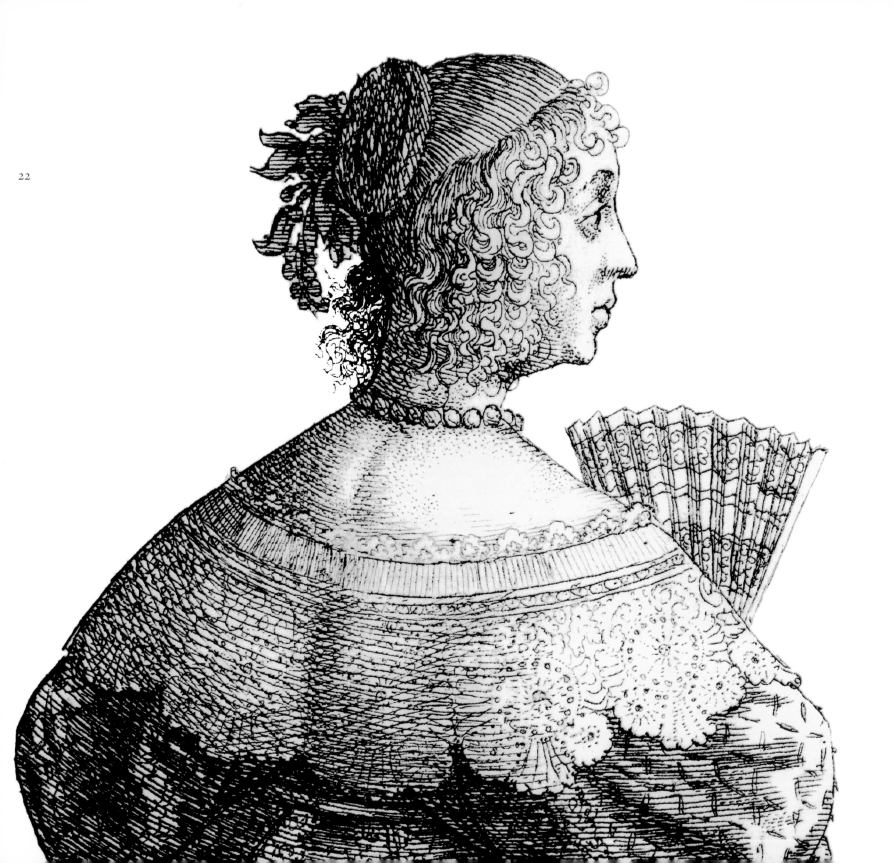

the years 1630 to 1636, and his Bowing
Gentleman (P1997), also published during
these years by Abraham Hogenberg, may
have served as a model for the figure of
the bowing gentleman on the *Academy
of Love* title page. Shortly after arriving
in England, Hollar began work on his
sketches for the twenty-six plates of the
*Ornatus Muliebris Anglicanus, or The Severall
Habits of English Women* (P1778–P1803).
They were published in 1640 and mark
the beginning of Hollar's association with
the printseller Peter Stent, whose name
appears on state two of the title page.
The first part of the *Aula Veneris* series of
European women (P1804–P1907) appeared
in London in 1642–1643 under the title
Theatrum Mulierum, just after Arundel, dis-
couraged by the situation in England, had
moved to Antwerp, taking his collection
with him. The remainder of the series
was published in Antwerp when Hollar
moved there in 1644. Both series demon-
strate Hollar's talents as a miniaturist; the
Ornatus Muliebris Anglicanus in particular
captures the play of motion and light on
shimmering gowns and the exquisite detail
of fine lace and rich furs.[23]

Hollar's portraiture, like that of many
of his English contemporaries, was weak.
The faces he created with his etching
needle have a common flatness. His best
results were achieved when he copied
faithfully from another source, particularly
an inspired source, which he had in Arun-
del's collection of paintings. Consider his
portraits of Pietro Aretino after Titian
(P1346), The Woman with Coiled Hair
from the painting by Dürer (P1536), and
Hans van Zürich after Holbein (P1411),
which he etched later in the 1640s. It is
surprising, therefore, that he managed to
capture a tangible grace and enigmatic
beauty in the features of his highly
acclaimed Seasons (P606–P617). Was this
the peak of Hollar's imaginative efforts,
a moment of brilliance that could not be
sustained nor repeated? Certainly many
aspects of the series demonstrate his great-
est talents: his rendering of texture, and his
patient and laborious attention to detail.

It has always been assumed that the
Seasons were fanciful creations, and yet it
is interesting to note that Hollar's three-
quarter length figure of Spring (P610)
looks remarkably similar to his unfinished
portrait of Henrietta Maria (P1537), copied
from a painting by Sir Anthony Van Dyck.
Could it be that Hollar used models for
these series from other artistic sources? Is
it possible that he recognized his weakness
and compensated accordingly?

The Seasons were produced about the
time Hollar married Mistress Tracy, a lady-

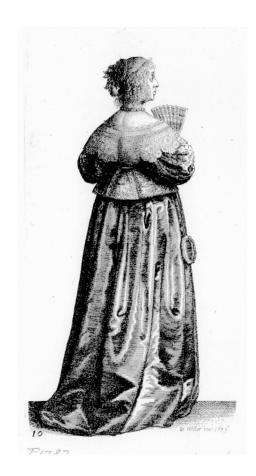

23

in-waiting to the Countess of Arundel. J. L. Nevinson has suggested that the long, pointed bodices of the Seasons were influenced by the Countess's taste in dress, while the high-waisted styles represented in the earlier plates of the *Ornatus Muliebris* were associated with Henrietta Maria.[24] By the time Hollar was working on the Seasons, Henrietta Maria was in disfavor and, in any case, he could observe more about taste in fashion in the Arundel household.

Why did Hollar have such a fascination with fashion, costume, and accessories? There are probably two reasons: first, in the English portrait market, the ideal was one of reserve and cool, detached elegance, with an emphasis on raiment rather than emotion, a dramatic contrast to the baroque style of Catholic Europe; secondly, and perhaps more plausibly, Hollar's rendering of fine detail provided a vehicle for his greatest talents. He dazzles the eye with the intricate and delicate array of lines that form his lace collars, fur muffs, bodices, and jewels. Hollar knew what he was good at and, fortunately, the market was his ally.

The Earl of Arundel left England in February of 1642 only months before the conflict between king and parliament escalated into serious military confrontation. It was at this time that Peter Stent opened his print shop outside Newgate.[25]

In England's unsettled political climate, the renascence in art stimulated by the Caroline court had more or less come to a halt, so while Stent's stock included copies of works of art, he catered to a clientele that was more interested in revolutionary political and religious ideas and in the growing civil conflict. The prints to the *Ornatus Muliebris* and *Theatrum Mulierum* series that Stent sold remained informative, illustrating current fashions of court and city and the dress of other parts of the world. They continued to be popular long after tastes in fashion had changed.

Just how immediately Hollar was affected by the loss of Arundel's patronage we do not know. He was serving as drawing master to the young Prince of Wales, but it must have been some relief to him to be able to turn to the London book- and printsellers for work. What Hollar would be asked to produce for Peter Stent and Thomas Jenner, one of Stent's competitors, would divert some of his attention away from fashion and landscape and toward politics.

From Fashion to Politics

Unlike earlier printsellers, Peter Stent was neither an artist nor an engraver, nor did he conduct his printselling business in addition to some other form of work.

Rather, he intended his to be a successful commercial venture that catered less to the connoisseur than to the average man on the street. The inexpensive maps and portraits that Stent sold permitted everyone to follow the progress of the Civil War and the major personalities on each side. Some were by Hollar, usually from plates Stent acquired second hand, but most were by lesser artists.[26]

Thomas Jenner, who had been in business since the 1620s, became one of Stent's chief rivals. In 1642, he published *All the memorable & wonderstrikinge Parliamentary mercies*, a pamphlet by the Puritan writer John Vicars that contained what are now some of Hollar's least-known etchings (P491A). It is difficult to associate these roughly drawn and poorly printed illustrations with the artist who only a year earlier had produced the three-quarter length Seasons. It seems clear, however, that Hollar was willing to produce what Stent and Jenner required because he needed the work. Hollar was nothing if not adaptable. Although he must have been a royalist, he etched portraits of figures on both sides of the conflict and turned out the plates that Jenner and others needed for their newsbooks, even when the bloody events he was asked to depict must have been abhorrent to him.

Spring, 1641 (P610).

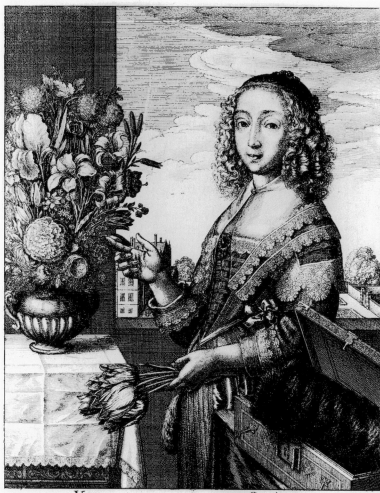

Henrietta Maria, after Van Dyck (P1537).

26 Many of the newsbooks and broadsides
of the period were illustrated with crude
woodcuts that

> . . .did enchant
> *The fancies of the weak, and ignorant,*
> *And caus'd them to bestow more time, and coin*
> *On such fond pamphlets, than on books divine.*
> (George Wither)[27]

Tamsyn Williams has examined "popular"
images in the pamphlet literature of the
Civil War years, images designed to appeal
to a very broad audience. They often were
intended to ridicule or embarrass one
faction, while congratulating another;
their messages were obvious. Because the
images themselves were crude rather than
realistic, they could more easily be used
to illustrate crude, rude, or violent subject
matter.[28] Jenner must have instructed
Hollar that these were the kinds of images
he wanted.

 In their original form, Hollar's plates
for *All the. . .Parliamentary mercies* consisted
of two scenes, one above the other, with
explanatory text included in the design.
They reappeared in other pamphlets by
Vicars at least through 1660, sometimes
cut in half and used in different contexts
and with different texts. One, in its earliest
state, depicted "The Earle of Strafford. . .

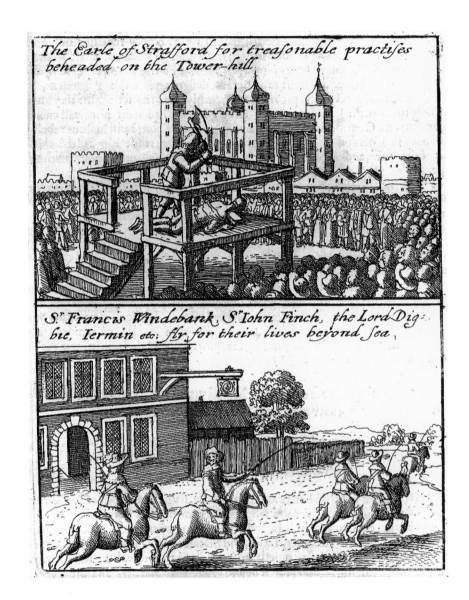

State 3 of top half of the previous print. The plate was cut in half and badly worn; the buildings were re-outlined; the original inscription was imperfectly erased.

State 2 of bottom half of the print. The plate was reworked, and the inscription was changed.

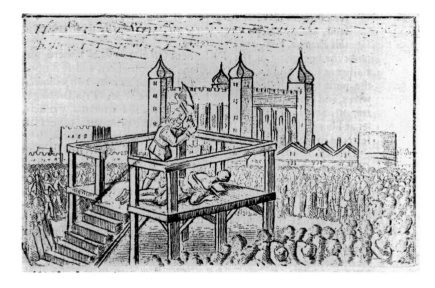

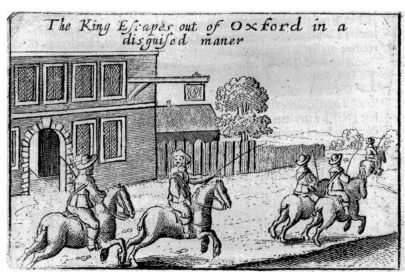

beheaded on the Tower-hill" above a scene captioned, "Sr. Francis Windebank, Sr. John Finch. . .fly. . .beyond sea." The plate has been cut in two in its second state, and the lower half of the plate, still showing five horsemen dashing through a village, has a new inscription, "The King Escapes out of Oxford." These plates were frequently and poorly reworked, and the captions were often imperfectly erased. Once the etched plates had left the artist's hands, they were the property of the printer. Copper for plates was scarce because of the war, so Stent and Jenner did not hesitate to buy up old plates and to employ journeymen to rework them to suit their immediate needs.[29] Hollar must have known how his plates would be used, which is perhaps the reason he did not sign them.

A similar series of prints by Hollar also appeared in 1642 in *The Teares of Ireland* (P491B), a pamphlet often attributed to James Cranford; it is an exaggerated account of the sufferings of Protestants in Ireland at the hands of Irish Catholics in 1641. Hollar's etchings, undoubtedly turned out quickly to meet the demand for news, match the text. In one print, two children are roasted over a fire while their parents are forced to watch. In another, soldiers with swords slash a dead woman's body to see who can make the deepest cuts.

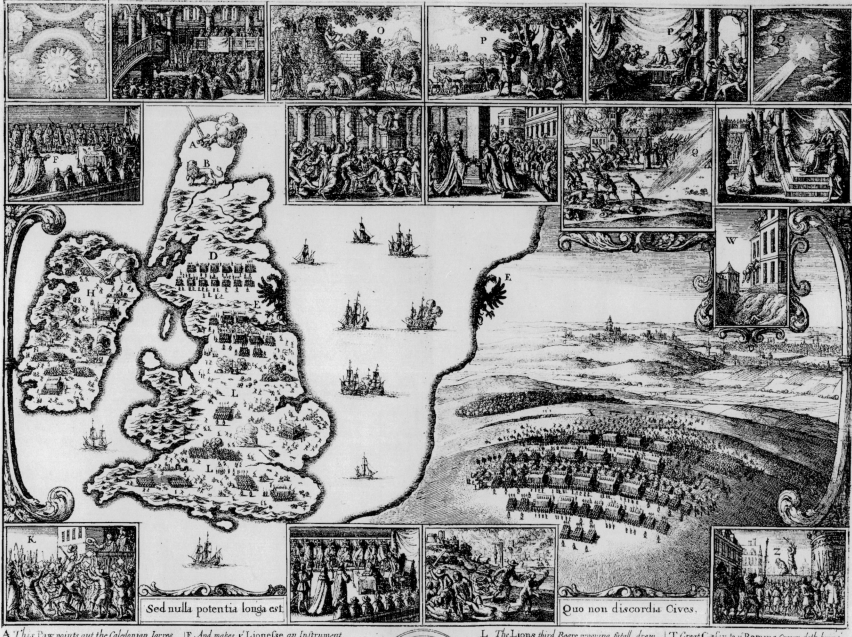

Sed nulla potentia longa est.

Quo non discordia Cives.

A This Paw points out the Caledonian Iarres,
 Sad Harbingers to our intestine Warres,
B The Lion passant gardant wonders much,
 The Paw should dar presume his Chiefe to touch.
C Strange y from Stooles at Scotish Prelates hurl'd
 Bellona's dire Alarms should rouse the World?
D The Lion & y Paw bent to change y Scene & Stage,
 Make Peace at Tweed, so change y Scene & Stage,
L The double headed Eagle wide doth spread
 Her Wings, to fan the Coales y seem'd as dead.

F And makes y Lionesse an Instrument
 To breake that Peace and a fourth Parlament.
G The Paw invades y Lion at Tine Flood:
 They fight, make Truce & stop from shedding Blood:
H The British Notes sound flat to those more sharp
 Divisions, ech'od from the Irish Harp.
I The Parlament convend the Lion tyr'd
 By Charming Five. The Members to divide
K First Iustice next no Bishops Priviledge last,
 Cry Multitudes who to the Houses haste,

L The Lions third Roare proving fatall, drew
 Such Woes, as rarely former, Ages knew
M Twas a Curst Cow kicks down y Milk shee gaue,
 Let us old Englands Lawes and Freedome haue.
N Celestiall Manna: thy Spirituall Food
OP Fed them with Peace & Plenty, all that's Good.
Q A blazing Comet thy Backsliding shewes
R Predicteth Ruine & presentetn woes
S The Faithfull build them Churches but are stopt
 By Papists, who at th Armes Brulla mockt.

T Great Cæsar to y Romans Crown doth bring
 His Stately Nephew and creates him king.
V Prague giues y Crown to Frederick & excites,
 His Sword to assert the Germans & their Rights
W Then from high Windowes unawares were thro'
 The Emperors Counsell ere the Chance was known
XY The Blow neer Prague was strucke The people ride
 Like Iehu out, Warre is sworne before t is try'd
Z What Desolations then, What Blood, What far
 Quinted Tragick Scenes enfu'd that Warre.

About this time, Hollar produced his most directly personal statement on the English Civil War, his Map of England and View of Prague (P543). It depicts, more than most of his Continental views, the political realities of Hollar's own experience. On the right is a bird's-eye view of the Battle of the White Mountain, 1620; on the left is a map of England with scenes from the beginning of the Civil War. The verses beneath are not by Hollar but must have echoed his feelings:

The blow neer Prague was struck. The
 people rides
Like Iehu out, Warre is sweet before t'is try'd.
What Decollations then? What Blood?
 What far
Outacted Tragick Scenes ensud that Warre.

Hollar was profoundly affected by each of these wars. In the aftermath of the Battle of the White Mountain, Hollar made the decision to leave his homeland. It was as a consequence of the same battle that the Earl of Arundel had been sent on the mission that Hollar joined in 1636. Now, the English Civil War would leave him without the patron who had brought him to England.

From London to Antwerp

In 1643 and 1644 Hollar issued the *Amoenissimi, Aliquot Locorum in diversis Provincijs iacentium Prospectus*, views of German cities and the Rhine (P719–P726), and another set of views of Germany and the Low Countries (P763–P774). He was still in London, but it seems that his thoughts were turning toward Europe. Sketches from his years in Germany were now put to use, and Godfrey suggests that Hollar realized he might have to leave England in order to market his work, unless he wanted to continue to illustrate the numerous pamphlets flowing off London's presses.[30] In Civil War London, people's interests centered on news rather than art, and the Puritan faction in parliament was openly hostile to the king's collecting, disapproving of the collection's representations of pagan antiquity and of any art that glorified the Church of Rome. In March of 1643 a committee of the House of Commons had thrown an altarpiece by Rubens into the Thames.[31] Although his own work was largely secular, Hollar must have found the atmosphere in London oppressive and frightening.

Antwerp had long been a flourishing center for the creation and marketing of art. In the early years of the seventeenth century, the studios of Antwerp painters, particularly that of Rubens, had drawn English collectors to the city. It was to Antwerp that Arundel had taken his collection in 1642. By 1644 Hollar had made the decision to leave London and had sold a number of his copperplates to Peter Stent to help finance his travel. He made his way to Antwerp but found that Arundel was ill and would soon move to Padua. Although the Countess remained in Antwerp and began to sell some of the famous collection to support herself, it is not clear whether Hollar had any contact with her.

During the next eight years, Hollar produced many etchings of works in the Arundel collection that must have been based on drawings made when the collection was in London. They are some of Hollar's best work and seem to reflect the serenity and security of Hollar's London years and the profound pleasure he took in copying the masters. It is likely, too, that Hollar benefited from the stimulus of being with other artists in the workshops of Antwerp. Some of the Antwerp prints were published by Hendrik van der Borcht, who had accompanied Arundel to the Continent.

Although Hollar grew up in a city dominated by a mannerist tradition in the arts, it was with the naturalism of the

30 Northern European schools that he identified. Holbein's portraiture influenced English taste for decades; even when he was not copying Holbein, Hollar exemplified aspects of his style. Consider Hollar's various portraits of Prince William, which share common stylistic themes with Holbein—an air of detachment, a static pose, and intricately executed costume and adornments. Holbein's influence on Hollar was not restricted to portraiture, however. He was also the source for Hollar's Dance of Death (P233–P266), a series of thirty-three etchings produced in 1651 in Antwerp.

Originally the Dance of Death was a fourteenth-century morality poem of a dialogue between Death and representatives of all classes of society. By the fifteenth century, depictions of Death leading his victims by the hand were painted on the walls of churchyards and cemeteries. It was probably in the erudite environment of Basel that Holbein made his original drawings for the Dance of Death about 1525. The woodcuts were executed by the master-engraver of Luxembourg, Hans Lutzelberger.[32]

The work became popular, and several editions were printed, frequently with new woodcuts by other artists. Hollar referred to two editions when he etched his series,

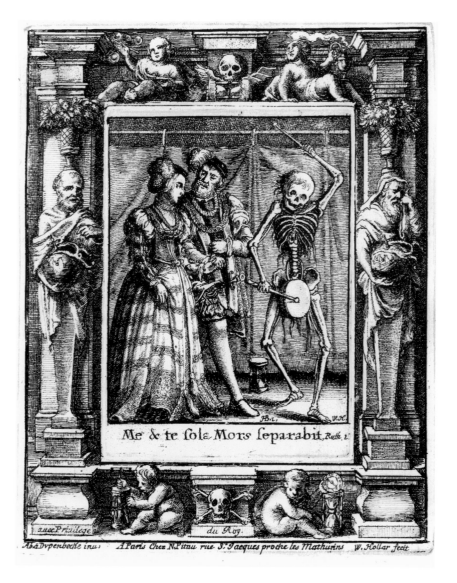

perhaps because the editions he had were imperfect.[33] Each etching was printed from two plates because the prints themselves were enclosed in one of three borders designed by Abraham Diepenbeeck.

Once again we have an example of Hollar's virtuosity during his Antwerp years. The images are almost miniature and depict Death as a prancing skeleton wreaking havoc indiscriminantly among the proud and the humble. The series served to illustrate that Death conquers all and is the tyrant of human existence. Hollar drew on already established talents in his depiction of the fashionably dressed, namely the Bridal Pair (P252), and he paid close attention to background and buildings, as in the image of the Duke (P241). Uncommonly for Hollar, however, the people he depicted reveal something akin to emotion; and, although he copied Holbein's images faithfully, Hollar injected a macabre exuberance that was his own. If the remarkably protracted history of Hollar's Dance of Death and the longevity of his plates is any indication, this is one of Hollar's more successful and important works.[34]

In order to work in Antwerp, Hollar had registered with the Guild of St. Luke as a "plate cutter" and through the Guild undoubtedly was introduced to other

32 artists and printmakers in the city.[35] He collaborated with some of the other artists he met and probably found his associations with them helpful in marketing his own prints. Among those he became acquainted with were the landscape painters Pieter van Avont and Jacques van Artois and the engraver Paulus Pontius, a friend of Rubens. Hollar collaborated with Pontius in the production of The Seated Huntress (P276) and The Sleeping Huntress (P277), after drawings by Van Avont. In these works, the figure of the huntress and her drapery were engraved by Pontius while the backgrounds were etched by Hollar. The delineation between techniques is clearly visible, and the plates bear the names of both artists. The printmakers' collaboration was appropriate because Van Avont, who created the original drawings, was noted for painting figures in landscapes by other artists.[36] The three hounds etched by Hollar around the seated huntress were drawn from his series of hounds, also after Van Avont (P2047). This was probably Hollar's first collaborative work. He would collaborate again in the future as artists and printsellers recognized the obvious advantages of joint artistic ventures.

Hollar clearly had not forgotten London during his Antwerp years, for he issued

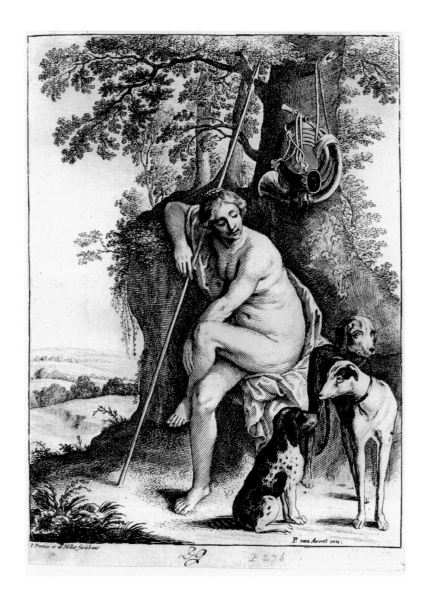

several views of London and the English countryside, which may have been aimed at English expatriates on the Continent. Probably the most remarkable product of Hollar's years in Antwerp was his Long View of London (P1014), completed in Antwerp in 1647 and published in Amsterdam by Cornelius Danckers the same year. Printed from six plates that form seven sections, it shows the entire city of London in one long panorama with the Thames at its center. No other view of London gives us such a complete picture of how the city looked before the Great Fire of 1666.

Topographical city views, like maps, serve to locate landmarks relative to each other. The Long View of London continues to be used to study the architectural history of pre-Fire London. In *The Quest for Shakespeare's Globe*, theater historian John Orrell deduces from Hollar's preliminary sketches of the Long View that Hollar must have used a "drawing frame" to achieve proper perspective.[37] Such a device had been described by Leonardo and named a *velo* by Alberti. Albrecht Dürer, with whose works we know Hollar was familiar, illustrated the device in *Underweysung der Messung*. Orrell's claim that the Long View could not have been drawn, and later etched, without a tool to ensure the precision Orrell finds in it is surely

A drawing frame, as illustrated in J. B. [John Bate], The Mysteryes of Natvre and Art, *1634.*

Another view of a drawing frame, from Albrecht Dürer, Underweysung der Messung, *Nuremberg, 1538.*

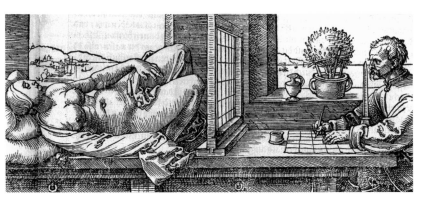

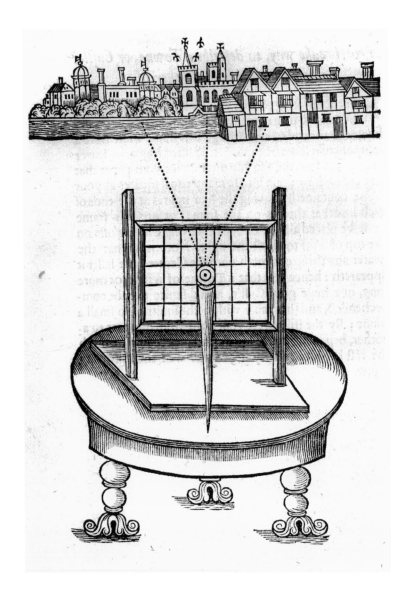

strengthened by Hollar's own statement in 1660 that he would produce a great map "proportionably measured."

Nearly everyone who has described Hollar's Long View has commented on the *putti* floating in the sky above the city, representing the areas of the world with which the city of London traded. These lifeless little figures are insipid and unfinished-looking compared to the extraordinary detail and precision Hollar achieved in depicting the city itself, its buildings, and the life and movement in the streets and lanes and on the river. Could Hollar have permitted another hand to etch these figures, or, more likely, might he have copied them from someone else's drawings? Pieter van Avont did a series of children and *putti* that bears some resemblance to the figures in the Long View; indeed, Hollar had etched some of them two years earlier (P492–P526).

England Again: Hollar and Ogilby

By the beginning of 1652, Hollar was back in England. He may have felt that the political situation had stabilized enough for him to return, or he may simply have failed to establish himself as an independent artist in Antwerp. Whatever the reason for his return to England, he soon found himself employed by the publisher

John Ogilby and the antiquary William Dugdale. Graham Parry has suggested that Dugdale persuaded Hollar to return because Dugdale needed Hollar's "accurate and sensitive hand" to illustrate his history of St. Paul's Cathedral and several other works.[38] Over the next twenty-five years, Hollar would etch no fewer than 566 plates for Dugdale and Ogilby.[39] By 1652 Hollar probably had begun work on Dugdale's *Antiquities of Warwickshire*, *The History of St. Pauls Cathedral*, and the *Monasticon Anglicanum* and was already etching plates for Ogilby's deluxe edition of Virgil.

The publisher John Ogilby led an extraordinary life. He began as a dancing master in London but, after an injury made him lame, became a theatrical manager and in the 1630s Master of Revels in Ireland. There, in Dublin, he was responsible for building a theater and forming a company of actors that was moderately successful for a few years. The venture came to an end with the Irish Rebellion of 1641, however, and in the mid-1640s Ogilby was back in England where he began studying Latin and Greek. By 1649 he already had published a translation of the works of Virgil that was favorably received. He must have had plans for the lavish folio edition of the works that would appear in 1654, for

his preface stated that he hoped that time would "ripen more ornament of Sculpture and Annotations."[40]

For the 1654 edition, Ogilby commissioned illustrations by a number of artists, including Francis Cleyn, who prepared most of the designs.[41] Hollar etched forty-three of the plates and the dedication and arms on eleven others. Many of the remaining plates were signed by Pierre Lombart, a French engraver. Ogilby evidently wanted to secure the profits from the sale of the book for himself, rather than seeing most of them go to a bookseller. He had subsidized the illustrations, the paper, and the costs of printing by obtaining subscriptions in advance from one hundred subscribers, each of whom would have his title and arms on one of the plates. The book was printed "for the author" by Thomas Warren, and copies could be purchased only at Ogilby's house in King's Head Court within Shoe Lane. It seems a risky kind of publication to undertake in England in the 1650s. As Katherine Van Eerde has pointed out, however, while ostentation of any sort was suspect, classical learning was irreproachable and, as Ogilby must have been well aware, saleable.[42]

Collaboration between printmakers reached its height in the eighteenth century,

but even in the seventeenth century it was not uncommon.[43] The combined techniques of etching and engraving on the same plate result in a sense of depth that bestows a more three-dimensional quality upon the image than could be achieved with one technique alone. Etching was suitable for landscape and backgrounds. The progress of the needle on the plate was faster than that of the engraver's burin, and the lines it produced could be finer. The overall image was unrestrained, but unless the etcher labored with crosshatching, it was essentially flat. Engraving, with its clear, regular lines, was particularly apt for figures. Volume was rendered in rich, curving forms that appear almost sculpted and are stylistically closer to prevailing artistic trends of the baroque period.

Some artists trained in both techniques, but it was more usual for them to concentrate their efforts on perfecting either etching or engraving. Hollar's *oeuvre*, as we know, was etched, and his only use of the burin was in retouching his plates. When he collaborated with Paulus Pontius, both names were on the plates. In many cases, however, only one of the collaborators was acknowledged for his work on a plate. In the print of Aeneas and the Golden Bough (P311) in Ogilby's Virgil, for example, the composition is typical of Hollar, and his delicate lines are unmistakable. The figure of Aeneas is undoubtedly engraved, however, and is apparently from the hand of William Faithorne.[44] Nonetheless, the plate was signed only by Hollar.

There is evidence in the Virgil illustrations signed by Pierre Lombart that Hollar, too, was responsible for work for which he received no credit. At least half of each image—essentially the foreground—is engraved, but closer scrutiny reveals that the background is composed of the loose, fine lines that we associate with the etcher's free use of the needle, and more specifically, with the bucolic landscapes of Hollar. To illustrate the point, magnified details of the Lombart prints may be compared to details of the prints by Hollar. In the photomicrographs of the two backgrounds, one by Hollar, the other etched but part of an engraved plate by Lombart, we can see many similarities (see p. 38). There has been no previous attribution of any of this work to Hollar, yet details of the foliage and buildings from both prints suggest that they are from the same source.

Little seems to be known about Pierre Lombart. He was born in Paris, where he learned engraving, but went to England in the early 1640s. Like Hollar, he spent part of his working life in London. He began as a journeyman and eventually achieved some reputation as a line-engraver. He is best known for his set of the ten Countesses after Van Dyck (issued exactly a decade after Hollar's three-quarter length Seasons) and for an engraved equestrian portrait of Oliver Cromwell. Lombart reworked the portrait at least three times; it exists as Louis XIV, Charles I, and also as a headless state—hence its designation, The Headless Horseman. In George Layard's study of The Headless Horseman, his assessment of Lombart's skills may help to explain the nature of Lombart's work on the Ogilby Virgil. According to Layard, Lombart was a capable engraver but a poor original draftsman. Significantly, Layard criticizes Lombart's "feeble background" in The Headless Horseman portrait.[45]

Joseph Strutt states that Lombart executed his plates entirely with the burin.[46] We cannot confirm that he never etched; yet, could he have etched the backgrounds of the plates he signed? It is unlikely he mastered the technique and more plausible that he received the plates for engraving with an etched image already on them. Did the etcher limit himself to the background, leaving a blank area for the engraver to fill in? Or did he etch the entire plate, parts of which Lombart later engraved over and took the credit for?

Alexis (P290) from John Ogilby's 1654 edition of Virgil. This plate was etched entirely by Hollar, who signed it.

Menalcas, Damoetus, and Palaemon (P290A). This plate was signed by the engraver Pierre Lombart. Pennington gives Hollar credit for etching the quotation, arms, and dedication under the illustration; yet the background of the image is also etched and appears to be by Hollar.

38

Details of the etched background from Hollar's plate of Alexis (P290).

Details of the etched background from Lombart's plate of Menalcas, Damoetus, and Palaemon (P290A).

Detail from Lombart's plate (P290A) with engraved lines over etched lines.

Under magnification there are intriguing hints that the latter may have been the case.

How might such a collaboration, if willing collaboration it was, have come about? Ogilby was certainly a risk-taker and something of an entrepreneur. He could well have recognized the differing talents of the two artists—Lombart the engraver of portraits and Hollar the etcher of landscapes—and have capitalized on what was available to him. Or, he may have commissioned Hollar to etch all of the plates, was dissatisfied with the results, and passed them to Lombart for completion or reworking. Alternatively, Lombart could have been given the whole series but worked too slowly and, as a consequence, was too expensive for Ogilby. By soliciting Hollar to etch part of the plates, and thereby reducing the amount of engraving on them, Ogilby could have reduced his costs.

Perhaps a collaborative effort was intended from the outset. Lombart and Hollar must have been working on their commissions for Ogilby simultaneously, possibly even in the same workshop. In fact, Hollar etched the lettering and arms on a number of the plates signed by Lombart. If Ogilby recognized an opportunity to create a superior product for his publication by combining the talents of engraver and etcher, he surely would not have hesitated to take advantage of it. Hollar's weakness in portraiture had not gone unnoticed, regardless of the number of commissions he received. For his portrait of Charles II as Prince of Wales, Hollar was directed to leave the face blank, presumably so that it could be executed by a more accomplished artist.[47]

What factors influenced who signed the plate? Was it designated by the amount of labor each printmaker put into the image? Generally the engraver was perceived as the more accomplished of the two artists. It could be that the last hand to work the plate was awarded authorship. Whatever the scenario, Ogilby was probably instrumental in the final decision. There are questions here that deserve further investigation. In the meantime, however, it seems likely that there is more of Hollar's work in the Ogilby Virgil than previously has been attributed to him.

There is no question that John Ogilby was proud of his edition of Virgil. In the preface to his *Africa* (1670), he described his achievement:

From a Mean Octavo, a Royal Folio flourish'd Adorn'd with Sculpture, and Illustrated with Annotations, Triumphing with the affixt Emblazons
Names, and Titles of a hundred Patrons, all bold Assertors in Vindication of the Work, which (whate're my Deserts) being Publish'd with that Magnificence and Splendor, appear'd a new, and taking Beauty, the fairest that till then the English Press ever boasted.[48]

Ogilby re-used the plates from the 1654 Virgil in a 1658 edition of the Latin text printed by Thomas Roycroft. The Latin text was reprinted in 1663 with the same plates, and they were used again in a 1668 edition of the English translation. In each case there were some alterations to dedications. Then, in 1697, these plates were used in a new edition of Virgil translated by Dryden and published by Jacob Tonson, who must have purchased the plates. In the illustrations where Aeneas appears, whether etched or engraved, his nose has been changed with an engraver's burin; he now has a Roman one like William III. This simple alteration was designed to compliment the king. The complicated and long history of Hollar's plates after they left his hands has been described by Pennington.

Hollar and Sir William Dugdale

When a revised edition of Henry Peacham's *The Compleat Gentleman* was issued in 1634, it contained a new chapter entitled "Of Antiquities" that was inspired in part by the Arundel marbles. The addition of the new chapter was a sure sign, says Graham Parry, that the subject of antiquities had become socially acceptable.[49] During the seventeenth century, antiquarianism had evolved from being the pursuit of a few studious scholars to the avocation of numerous gentlemen throughout England; their interest in the historical scholarship of the Renaissance coincided with a renewed interest in religious history and in national origins and identity. William Camden's *Britannia* of 1586 had demonstrated that valuable information could be gleaned from the study of ancient ruins, monuments, and graves and had provided a model for future antiquarian studies.[50]

Sir William Dugdale spent fifty years, from the 1630s to the 1680s, recording the development of British medieval institutions, including the monasteries. The study of monastic history essentially began with such seventeenth-century antiquaries, who tried to piece together from documents the history of the monasteries, the one great institution of medieval England that had been destroyed.[51] Dugdale had been interested in history and antiquities since his youth and had agreed to cooperate with Roger Dodsworth on a project to preserve monastic records.

During the 1640s, Dugdale became keenly aware of how vulnerable other kinds of documentary evidence would be under a Puritan government. Anything that smacked of popery—stained-glass windows, monuments, ornaments—might be in danger. Churches preserved in monuments, as well as in archives, the records of parish and county life. Determined to do what he could to preserve these records, Dugdale engaged an arms painter named William Sedgwick; together they documented all the monuments, copied epitaphs, and recorded arms in the stained glass windows at St. Paul's and Westminster Abbey. Having completed these records, Dugdale went on to Ely, Lincoln, York, Chester, and numerous other towns recording all that he could find "to the end that the memory of them (in case if that ruin then imminent might come to pass) ought to be preserved for future and better times."[52] By the 1650s Dodsworth and Dugdale were preparing the *Monasticon Anglicanum* for the press, but in 1654 Dodsworth died, leaving Dugdale to manage the cost of the printing on his own. Numerous fellow antiquaries and sympathetic friends came forward with donations for plates in the *Monasticon*.[53]

Fortunately for us today, Dugdale recognized the importance of the buildings. Although he did not describe them himself, he found artists to "preserve" them in plates for his publications; the illustrations to the *Monasticon* began a tradition of architectural antiquarianism.[54] Hollar's plates, whether views or ground plans, were the most accurate renderings of church architecture that had ever appeared in England, and they were prepared in the same spirit as Dugdale's text.

The *Monasticon* includes etchings by another artist, Daniel King, whose work is crude and inaccurate. His buildings are flat and isolated in space; there is no play of light around the corbels and arches and doorways that he hurriedly produced; and he frequently misinterpreted angles and perspective. King signed the view of the west front of Rochester Cathedral, yet the doorway of the Cathedral is etched with a level of precision and detail that is absent elsewhere in the print and is more typical of Hollar. Could this plate be another collaborative effort?

Although Hollar did not operate a workshop in which to train young artists, it is possible that King was working directly

with Hollar on the *Monasticon* commission.
Vertue wrote, "Others learn'd of Hollar,
and assisted him in his Works:—Carter,
Dan. King, and Gaywood. . . ."[55] It is
easy to imagine the master and apprentice
together, Hollar reviewing the novice's
work, then showing him how he should
etch a doorway using fine lines to render
shadow and depth. King apparently had
the patronage of Lord Fairfax, who must
have recommended him to Dodsworth.
Parry believes that this explains why there
are fewer King plates in the third volume
of the *Monasticon*, over which Dugdale had
complete control.[56]

The first volume of the *Monasticon* was
published in 1655 and of the sixty-nine
plates, only ten were entirely by Hollar.
Volume two, with nineteen etchings by
Hollar, came out in 1661, and volume
three, with thirty-two plates by Hollar,
in 1673. In the meantime, *The Antiquities
of Warwickshire*, containing 183 Hollar
etchings, had appeared in 1656. It was
followed in 1658 by *The History of St. Pauls
Cathedral.* Dugdale paid Hollar relatively
well: he usually received £3 from Dugdale
for each of his finished plates, and during
a five-month period in 1656, he received
£33 for his work. An average annual
income for Londoners would have been
about £21.[57]

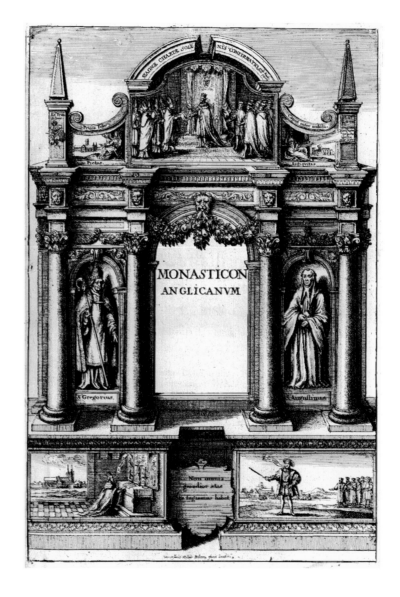

41

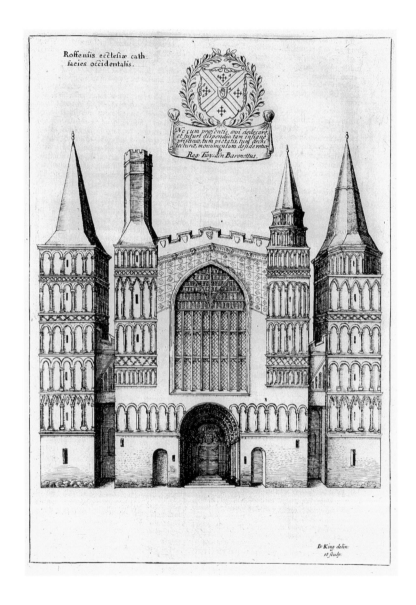

West front of Rochester Cathedral, etched by Daniel King, from Sir William Dugdale,
Monasticon Anglicanum, *volume 1, 1655.*

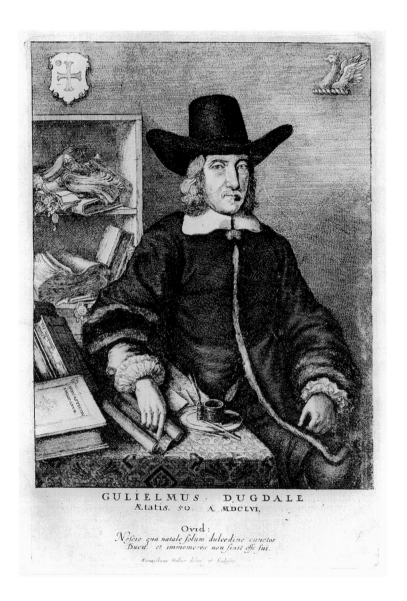

Sir William Dugdale (P1392), frontispiece to his The Antiquities of Warwickshire, 1656.

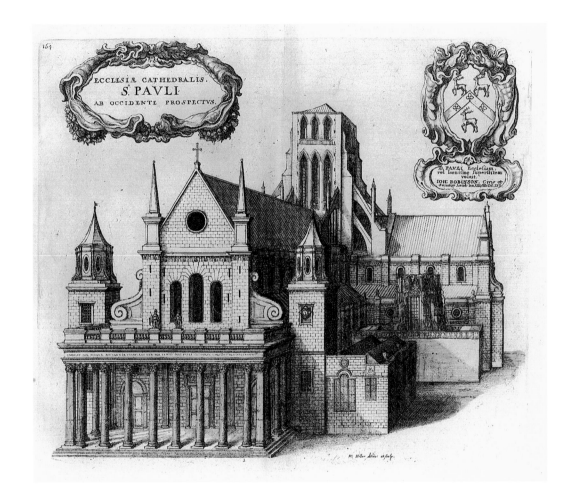

Hollar had a hand in most of Dugdale's works, and it would appear that the two were friends. There are numerous references to Hollar in Dugdale's correspondence.[58] Hollar's portrait of Dugdale (P1392) is one of his most interesting, and it seems to convey Hollar's affection for the man who was his principal patron after his return to England. It has none of the stiffness of some of Hollar's other portraits, and, possibly because Hollar knew Dugdale so well, his features and bearing are captured naturally. He sits at a table on which are his own publications, an inkwell, and pens. Beside him, on shelves, are books of notes and parcels of documents, and in his right hand he clasps a rolled-up manuscript. It is easy to believe that this is a pose in which Hollar often saw Dugdale.

Hollar's etchings of St. Paul's are the only accurate records we have of the interior of the Cathedral before the Great Fire of 1666. For John Aubrey, "That stupendous fabric of Paul's Church, not a stone left on stone, . . . lives now only in Mr. Hollar's etchings. . . ."[59] The St. Paul's depicted by Hollar was one of several incarnations. It is likely that the St. Paul's destroyed by fire in 1087 was not the first. By 1340, the Cathedral we see in Hollar's etchings had been completed; it differed from Hollar's, however, in that it had an enormous

timber spire, 124 feet higher than Wren's dome. The spire was struck by lightning and destroyed in 1561 and never replaced.[60]

Londoners could have constructed their lives around the ringing of St. Paul's bells and could have navigated the city using the Cathedral as a compass point. We know, too, that fashions were derived from the ornamentation of St. Paul's. The parish clerk of Chaucer's *Canterbury Tales* had "Paules windows carven on his shoes."[61] Those same windows were among the details of St. Paul's that Hollar illustrated for Dugdale's *History*. Hollar produced etchings of all sides of the exterior of the church, of the nave, choir, and crypt, and of tombs, monuments, and the glass.

At the time that Dugdale published the *History,* the whole building had fallen into a serious state of disrepair, having borne the traffic of London's citizenry for centuries. Hollar depicted the classical portico (P1020) erected by his friend Inigo Jones in 1623 as if just polished or swept, unused rather than occupied by the seamstresses who conducted their trade there. His lettering on the plate of the nave (P1025) expresses his concern for the building's condition, although he could not have anticipated its destruction by the Fire: "Wenceslaus Hollar the Bohemian, illustrator of this church (which daily

expects its fall), and once its admirer, will thus preserve its memory."[62]

As valuable as Hollar's etchings for Dugdale are, they lack some of the warmth and vitality of his earlier views; without human figures they fail to convey the role that St. Paul's played in the lives of the citizens of London. The contrast between the exterior views of St. Paul's and the earlier view of Antwerp Cathedral (P824) is dramatic. In the Antwerp view, catalogue no. 91, people walk along the streets, the stalls are open, a coach passes by, and there is even a group of dogs engaged in a playful fight. It may be that Dugdale did not want human figures in the plates, or it is possible that, because Hollar often was working from the drawings of others, he could not fabricate that kind of detail. Graham Parry suggests, and he is undoubtedly correct, that Hollar would have been reluctant to improvise details in illustrations dedicated to historical accuracy.[63] It is likely, too, that Dugdale's commission was accompanied by specific instructions.

In the early morning of September 2, 1666, fire broke out at a baker's shop on Pudding Lane. It traveled northwestward, reaching St. Paul's on September 4th. Years before, Inigo Jones had encased the Cathedral's walls in Portland stone, and had protected the roof with a lead wrap-

per. Londoners hoped the fire would not jump the churchyard, the largest open space within the city, but Jones's own portico practically abutted timber houses that caught the sparks that then were blown onto the unprotected timber roof of the portico. Booksellers, whose stalls lined the churchyard along Paternoster Row, moved their volumes and copperplates into St. Faith's, their guild church located in St. Paul's crypt. Once the fire had attacked the portico roof, however, it spread through the Cathedral; St. Paul's was doomed. The lead roof melted and crashed through the crypt ceiling while flames spread through the ground-level windows. Plates and books were melted and burned. Molten lead was said to have flowed river-like down Ludgate Hill. Pepys estimated that £150,000 worth of books and plates had been stored in the crypt; all were lost, including 300 copies of *The History of St. Pauls.*[64] Five of Hollar's copperplates for that volume were also lost. Edward Maynard recounted the obstacles he faced in preparing the second edition of the *History* in 1716. As Dugdale's grandson told him, "at the Fire at London, Five of the principal Plates were lost in the Hurry, that could never be recover'd by his Grandfather: And the other Plates, when we came to look into them, were general-

The interior of the crypt of St. Paul's (P1030), from Sir William Dugdale, The History of St. Pauls Cathedral, *1658.*

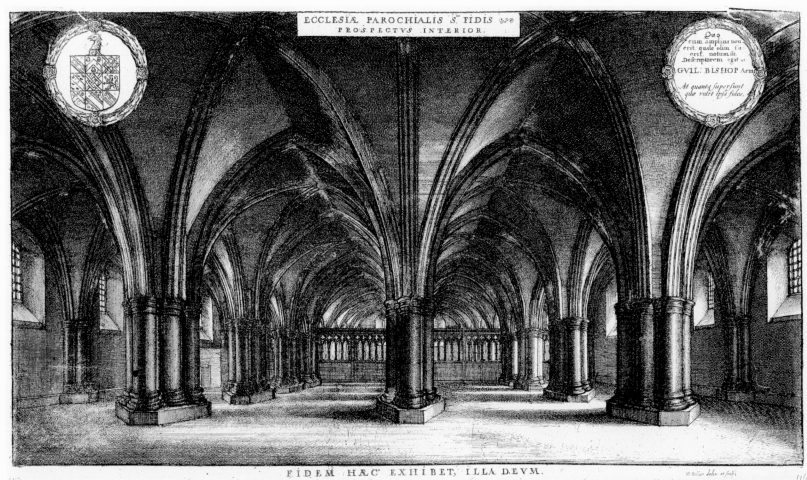

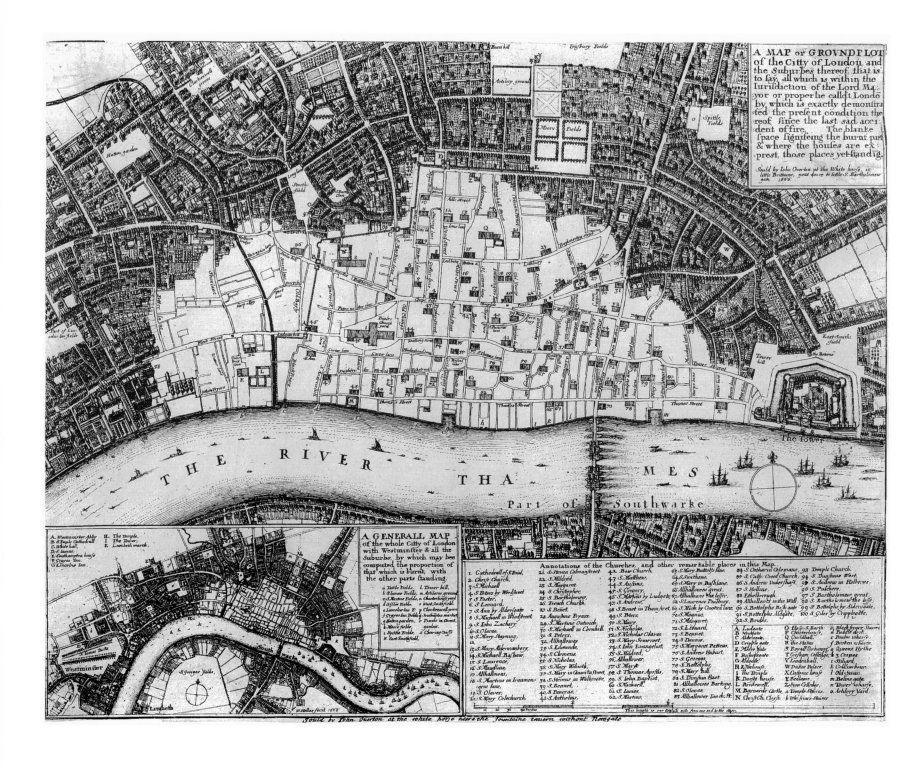

ly worn so smooth, that they would want to be Retouch'd (as the Engravers call it) to restore them to the Beauty they once had, (from the Hand of Hollar, the most noted Engraver of his Time)."[65]

Hollar would not have been able to return to the tower of St. Mary Overy, from which he had drawn the Long View, to draw the fire as it blazed through the city. He would have been in great danger. As a foreigner, he would have been suspected of being a Catholic, the first group accused of causing the fire. Nevertheless, the Fire created a demand for representations of the city as it was before, during, and after the destruction, and Hollar produced a number of plates that provided such documentation. His parallel plates of London before and after the fire (P1015) comprise a long view of the untouched city above a view of its charred and smoldering remains. Within months of the Fire, Hollar also etched two bird's-eye views of the destroyed city. John Evelyn claimed that the first (P1003) compelled him to alter the plans he intended to submit for the rebuilding of the city. The second, *A Map or Groundplot of the Citty of London* (P1004), is more extensive, depicting a broader area of the city. An inset view from a greater aerial distance is based on P1000.

In 1660 Hollar issued a small prospectus entitled "Propositions Concerning the Map of London and Westminster...which is in hand by Wentzel Hollar." The Folger Library owns the only copy of the prospectus known to have survived. It contains propositions for the production of a great map of London that was to have measured ten feet in length and five feet in height. The prospectus was intended to secure subscriptions to help finance the project. The Folger's copy is Hollar's signed receipt for a sum received from Sir Edward Walker, Arundel's secretary on the embassy to Vienna that had been so significant for Hollar nearly twenty-five years earlier: "I acknowledge to have received of Sr. Edward Walker, the Summe of 20 Shill[ing]es upon the Conditions aforesaid."

The map was intended by Hollar to be his masterpiece, one that would surpass all other maps of London. Although he survived the Plague of 1665, the Great Fire put an end to his plans.[66] He petitioned the king for the position of Scenographer Royal, hoping that would help him complete his project. He received the title, but no financial help.

The prospectus referred to an "Example whereof is in Considerable part to be seen." Does this suggest that the enormous project had begun? Does it refer to a previous map his audience was expected to know? Map historians have long debated the meaning of Hollar's phrase. The unfortunate reality is that no map of the proportions described by Hollar exists, although the large, twenty-plate map of London printed by Ogilby and Morgan in 1677, the year of Hollar's death, bears the artist's hand on some of the plates.[67]

Hollar's Final Years

Early in the 1660s, after issuing his prospectus for the great map, Hollar was once again working for John Ogilby. In addition to designing parts of the triumphal arches erected for Charles II's coronation, Ogilby recorded the celebratory events in *The entertainment of His Most Excellent Majestie Charles II, in his passage through the City of London to his coronation.* Hollar's etchings depict the royal cavalcade in narrow strips that together are 288 inches long (P570–P574). An unsigned etching of the coronation itself (P575) seems unmistakably to be Hollar's work. Possibly because of his recent success with the interior views of St. Paul's, Hollar emphasizes the majestic splendor of the setting, the vaulted ceiling, the arches, and the stained glass windows. The grandeur of the Abbey itself and the assembled ranks of nobles conspire to draw our eyes away

48

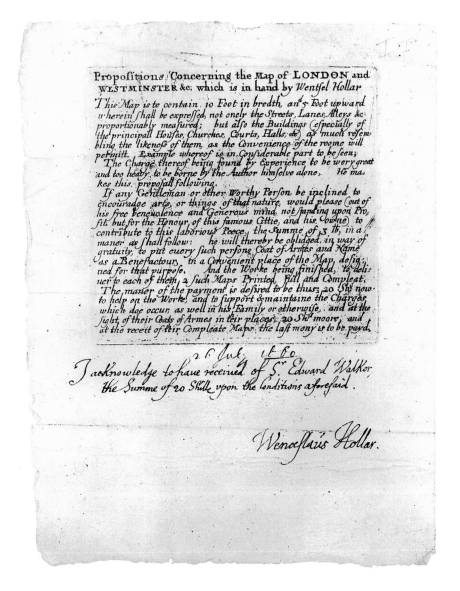

from, rather than toward, the figure of the restored monarch.[68]

In spite of an outbreak of Plague in London, Ogilby issued his large folio edition of Aesop's *Fables* in 1665. It contained eighty-two fables, each with a full-page illustration based on drawings by Francis Cleyn. Hollar provided fifty-seven, many of which are charming and humorous. Curiously, his interior scenes, "peopled" with animals, are a valuable record of the appearance and furnishings of seventeenth-century English rooms. A year after the Aesop was published, much of the city of London was destroyed in the Fire. It seems likely that Ogilby lost most of his stock of the Aesop, for he reissued it in 1668.

Hollar's limitations as an artist are demonstrated by inconsistencies in his work. Clearly, however, there was an economic factor at work as well: that is, the market that the publishers were targeting. The point is illustrated by two of Ogilby's editions of Aesop, published with his own *Aesopics, or A Second Collection of Fables.* The second collection was written by Ogilby, who described himself as "a Designer of my own fables." The edition published in 1668, also a folio, was illustrated largely by Hollar; fifty-seven plates were re-used from the 1665 edition, and of thirty-nine

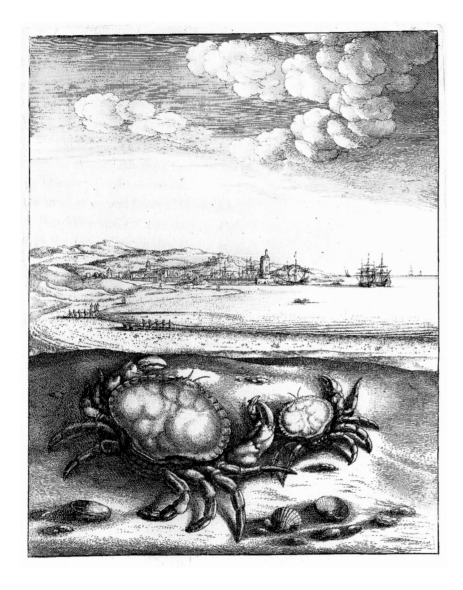

new ones, eighteen were by Hollar. Some of these are among his finest work. The etching for the fable of the crab and its mother (P397), for instance, borrows elements from earlier material, in particular the European views and the undated and very rare series of shells.

In 1673 Ogilby published an octavo edition of the fables that was evidently aimed at a different market. Apart from being smaller, it contains illustrations that are inferior in both their execution and their printing. The image accompanying the fable of the fox and the weasel (P364A) is barely legible, the plate so badly worn and reworked that it is difficult to associate it with Hollar. Yet, apparently, it is his work.[69]

Was Ogilby's reputation compromised by such poor printing? It seems unlikely. Ogilby was too shrewd to publish an, at best, uneven work unless he had a market for it. On the contrary, it seems that he recognized a gap at the lower end of his trade and acted accordingly. One wonders how Hollar felt. Did he know his plates were being used so many times? Were etchers like Hollar willing to rework previously published plates? It seems clear that Hollar did not normally rework his own plates, except perhaps minor retouching of the image upon completion of the

first state. The results of crude reworking speak for themselves. It was probably the labor of poorly trained apprentices. Regardless of how he felt, Hollar would have had no recourse. Once a plate left his hands he had no control over its printing. Only by printing and publishing his own plates could Hollar have dictated how his work was used, which is what the English engraver William Faithorne did, and with considerable success.

While he was turning out numerous plates for Ogilby, Hollar also continued his work on the third volume of Dugdale's *Monasticon*, which would appear in 1673, and he signed some of the plates with his new title, "Scenographus regis." He was, in addition, busy with work he had begun shortly before the Restoration on fifty plates for Elias Ashmole's *Institutions, laws & ceremonies of the most noble Order of the Garter*. Thus, in spite of the two great disasters of the 1660s, Hollar did not lack employment. If anything, the Fire brought him new commissions in addition to what he was doing for Ogilby and Dugdale.

In 1669, however, Hollar requested the permission of the king to travel to Tangier with an embassy organized by Lord Henry Howard (grandson of the Earl of Arundel):

with whose grandfather I lived in the like employment, . . . allow me £100 towards fitting myself and leaving my house and family in good condition, then I will adventure my person and time, and give an account of what is worthy to be observed in those parts. . . .[70]

Why Hollar wanted to risk travel to Tangier at the age of sixty-two is unclear. Maybe he wanted a break from his laborious work for Ogilby, Dugdale and Ashmole, or perhaps, as he said himself, he remembered his "like employment" on the earlier embassy to Vienna. In Tangier he was able to devote himself to work that was very different from what he had been doing in London, work that was reminiscent of what he had produced on the earlier embassy. During his months in Tangier, Hollar painted a series of delicate and accurate watercolors of the countryside and the English fortifications.[71] After his return to England, he produced etched views from fifteen of them, twelve of which formed a series entitled *Divers Prospects in and about Tangier, Exactly Delineated by W. Hollar, His Majesty's Designer* (P1187–P1202). Hollar's etched views of Tangier contain many elements of his English landscapes but lack their vitality. Perhaps it was because the landscape was barren, or because, as "His Majesty's Designer," Hollar felt compelled to "exactly delineate" the English settlement.

During the last few years of his life, Hollar worked on plates for volumes by Francis Sandford and Robert Thoroton. Sandford had been one of Hollar's fellow surveyors after the Great Fire, and for his *Genealogical history of the kings of England* he asked Hollar to produce twenty-three heraldic etchings. Hollar's final commission, to illustrate Robert Thoroton's *The antiquities of Nottinghamshire*, occurred when he was nearing seventy years of age. His hand was not as sure as it once was, and his eyes may have been failing as well. Certainly the precision that characterizes most of his work is lacking. Hollar died in 1677 before he had completed the *Nottinghamshire* plates.

We know little of Hollar's personal life and his psyche. His work suggests that he was an ingenuous character. He etched with candor and frankness, and he was constantly employed, and probably exploited, by the publishers and printsellers with whom he dealt. Even in his political subject matter he revealed nothing of his feelings. In his etching of the execution of the Earl of Strafford, he focused on the spectacle of the event; crowds of people are crammed around the platform to witness the beheading, against a backdrop of the Tower.

East end of Lincoln Cathedral (P994), from Sir William Dugdale, Monasticon Anglicanum, *volume 3, 1673.*

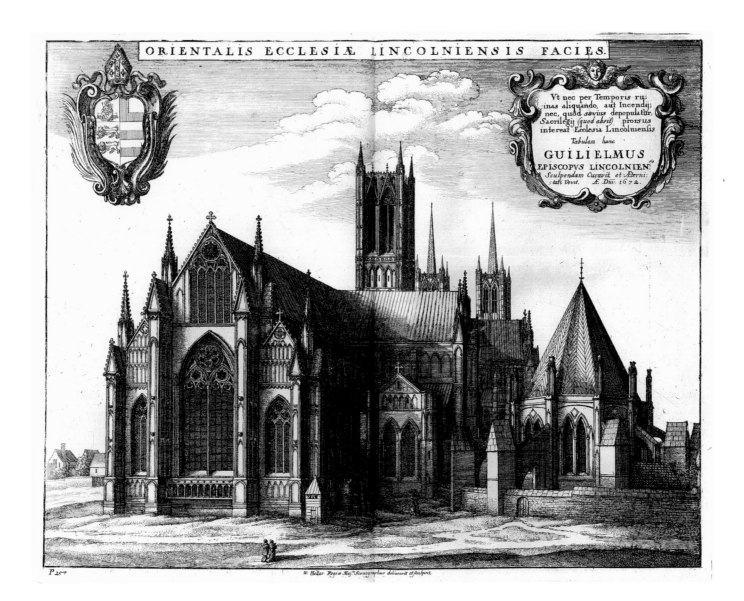

ORIENTALIS ECCLESIÆ LINCOLNIENSIS FACIES.

Vt nec per Temporis ru-
inas aliquando, aut Incendij;
nec, quod sævius depopulatur,
Sacrilegij *(quod absit)* prorsus
intereat Ecclesia Lincolnienssis
Tabulam hanc
GUILIELMUS
EPISCOPVS LINCOLNIEN.
Sculpendam Curavit, et Æterni-
tati Dovit. A: Dñi. 1672.

A veiled woman and a soldier seated at a table by a fire (P412), from The Ephesian Matron, *published with John Ogilby's* Aesopics, *1668.*

52 Only in one series of prints did Hollar stray from his usual formula, in *The Ephesian Matron* (P409–P418A), published with Ogilby's *Aesopics*. The text is from a romance in prose and verse by the Roman satirist Petronius. Here we can discern an emotional quality, quasi-spiritual, that is absent in Hollar's main body of work. He captured a mood with his use of tone, creating a chiaroscuro in the candlelit scenes of the matron and her wooer— a soldier who guards her husband's grave—to whom she succumbs. These etchings bring to mind the paintings of Rembrandt, not only in the features of the soldier that recall *Jacob Blessing the Sons of Joseph* (1656), and various helmet-headed figures, but also in the treatment of light. Hollar's plates were published in 1668. Their tonal qualities seem more akin to the mezzotint. John Evelyn introduced the mezzotint process to England in 1662, and it flourished there more than anywhere else at the end of the seventeenth century.[72]

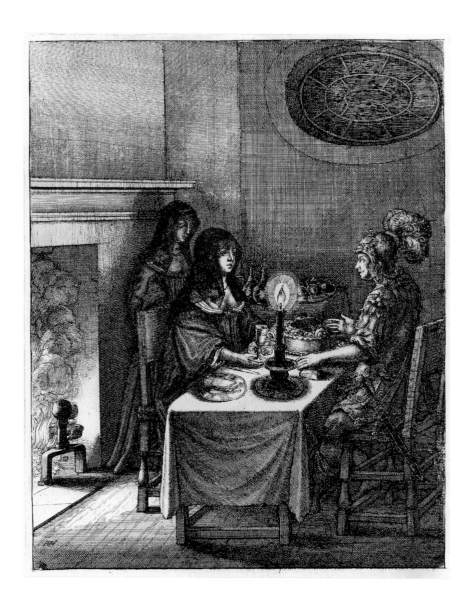

Students of the seventeenth century recognize their debt to Wenceslaus Hollar. His impressions, in all our understandings of that word, are a visual archive to be sifted and mined for evidence. Hollar brings us into the crowd, permits us to witness the spectacle of Strafford's execution or Charles's coronation. He shows us more intimate scenes as well: glimpses of a spartan bedchamber or a well-stocked larder, of a high-heeled shoe, an underskirt, the shape of a cap, or the cut of a sleeve. In his landscapes, of Cologne or Greenwich, of Coventry or Tangier, Hollar freezes for us an otherwise transient terrain that was shifting even as he rendered it and that has since been irrevocably altered.

As an etcher, Hollar should have been able to execute his plates in a shorter time than an engraver would have. He could draw and sketch freely onto his prepared surface, with the results being a looser style, a sense of freedom, a spontaneity, and a lighter hand. Hollar, however, was anything but spontaneous. Much of the speed gained from etching he probably forfeited by fastidious execution in pursuit of the meticulous detail that characterizes his finished plates.

Hollar's beginnings were in Prague, but most of his working life was spent in England. Surely, in his views of Windsor, in the Seasons, in his own words on the plate of St. Paul's nave, and in the extraordinary detail of the Long View of London, there is overwhelming evidence of Hollar's deep affection for his adopted country. Wenceslaus Hollar never forgot his homeland, however. One of his last etchings, known in only two copies, was a view of Prague based on a drawing made fifty years earlier. He was undoubtedly feeling nostalgic at the end of his long life, a life devoted to recording his surroundings.

The young Czech artist that the Earl of Arundel took to England in 1636 spent forty years recording his impressions of the turbulent era in which he lived. Treasures from the Earl of Arundel's art collection, the "stone upon stone" of St. Paul's, and the city of London Hollar knew, in Aubrey's words, "live now only in Mr. Hollar's etchings." The Earl of Arundel and the cognoscenti who gathered around him continued to influence Hollar throughout his life, and Hollar often was sustained by friendships that began at Arundel House, especially with Evelyn, Dugdale, and Sir Edward Walker. The paper museum Arundel envisioned but did not realize took shape in the larger vision of Sir William Dugdale and other seventeenth-century antiquaries, and in the visual documentation Wenceslaus Hollar created for them. The records on paper created by Dugdale and Hollar outlived the wood, stone, brass, and glass they sought to preserve. Wenceslaus Hollar labored hard for the publishers, the printsellers, and his patrons; he "dyed not riche." Yet his work serves today as a primary source in our quest to understand the century in which he practiced his art; it is an invaluable legacy.

Notes

1. See John Aubrey, *Brief Lives*, ed. Oliver Lawson Dick (London: Secker and Warburg, 1949), 162–163; John Evelyn, *Diary*, ed. E. S. de Beer (Oxford: At the Clarendon Press, 1955), 1:21–22; William Dugdale, *Life, Diary, and Correspondence*, ed. William Hamper (London: For Harding, Lepard, and Co., 1827). Francis Place's letter to George Vertue, May 20, 1716, is one of the most useful sources of information about Hollar, but it was written long after Hollar's death and contains some errors; it was reprinted in the *Walpole Society Annual* 18 (1929–1930), 34–35.

2. See Richard Pennington, *A Descriptive Catalogue of the Etched Work of Wenceslaus Hollar, 1607–1677* (Cambridge: Cambridge University Press, 1982); Richard T. Godfrey, *Wenceslaus Hollar: a Bohemian Artist in England* (New Haven: Yale University Press, 1994); Katherine S. Van Eerde, *Wenceslaus Hollar: Delineator of His Time* (Charlottesville: University Press of Virginia, 1970); Graham Parry, *Hollar's England: a Mid-Seventeenth-Century View* (London: Michael Russell, 1980); Vladimir Denkstein, *Hollar Drawings* (London: Orbis Publishing, 1979); George Vertue, *A Description of the Works of. . .Wenceslaus Hollar. . .with Some Account of His Life* (London: For William Bathoe, 1759).

3. Aubrey, *Brief Lives*, 162–163; Evelyn, *Diary*, 1:21–22.

4. See Godfrey, *Wenceslaus Hollar*, 1–4.

5. See Denkstein, *Hollar Drawings*, 28.

6. Ibid., 15; Godfrey, *Wenceslaus Hollar*, 4.

7. Godfrey, *Wenceslaus Hollar*, 4–5.

8. Ibid., 5–6.

9. Ibid., 7–9; see also Pennington, *A Descriptive Catalogue*, xxii–xxiii.

10. For a full account of the journey and a catalogue of the drawings, see Francis C. Springell, *Connoisseur & Diplomat. . .the Earl of Arundel's Embassy to Germany in 1636 as recounted in William Crowne's Diary, the Earl's Letters, and other Contemporary Sources* (London: Maggs Bros. Ltd., 1963).

11. Pennington, *A Descriptive Catalogue*, xxiii.

12. See David Howarth, *Lord Arundel and his Circle* (New Haven: Yale University Press, 1985); and David Jaffé, *The Earl and Countess of Arundel: Renaissance Collectors* (London: Apollo Magazine Ltd., 1995).

13. Franciscus Junius, *The Painting of the Ancients* (London, 1638), as cited in David Jaffé, *The Earl and Countess of Arundel*, 22.

14. George Vertue, *Note Books I. Walpole Society Publications*, XVIII (1930), 47.

15. Jaffé, *The Earl and Countess of Arundel*, 12, 20.

16. Henry V. S. Ogden and Margaret S. Ogden, *English Taste in Landscape in the Seventeenth Century* (Ann Arbor: University of Michigan Press, 1955), 2–3.

17. Pennington, *A Descriptive Catalogue*, xxvii.

18. Howarth, *Lord Arundel and his Circle*, 32.

19. Henry Peacham, *The Compleat Gentleman* (London, 1622), as cited in Alan R. Young, *Henry Peacham* (Boston: Twayne Publishers, 1979), 19.

20. For a fuller discussion of Henry Peacham's writings about art, see Young, *Henry Peacham* (Boston, 1979), and F. J. Levy, "Henry Peacham and the Art of Drawing," *Journal of the Warburg and Courtauld Institutes* 37 (1974), 174–190.

21. Aubrey, *Brief Lives*, 163.

22. Godfrey, *Wenceslaus Hollar*, 14.

23. For a discussion of possible sources for Hollar's costume series, see Godfrey, *Wenceslaus Hollar*, 13–14.

24. See J. L. Nevinson, *The Four Seasons* (King's Lynn: The Costume Society, 1979), 7.

25. Alexander Globe, *Peter Stent, London Printseller* (Vancouver: University of British Columbia Press, 1985), 1.

26. Ibid., 3–13.

27. George Wither, *The Great Assises Holden in Parnassus* (London, 1645), as cited in Tamsyn Williams, "'Magnetic Figures': Polemical Prints of the English Revolution" in Lucy Gent and Nigel Llewellyn, eds., *Renaissance Bodies: The Human Figure in English Culture, c. 1540–1660* (London: Reaktion Books, 1990), 86.

28. Ibid., 86–87.

29. Globe, *Peter Stent*, 26–32.

30. Godfrey, *Wenceslaus Hollar*, 17.

31. See Jonathan Brown, *Kings & Connoisseurs: Collecting Art in Seventeenth-Century Europe* (Princeton: Princeton University Press, 1995), 10.

32. Hans Holbein, *The Dance of Death*. A complete facsimile of the original 1538 edition, with a new introduction by Werner L. Gundersheimer (New York: Dover Publications, 1971), x.

33. Pennington, *A Descriptive Catalogue*, 29.

34. Ibid., 29–30.

35. See Jacqueline Burgers, *Wenceslaus Hollar: Seventeenth-Century Prints from the Museum Boymans-Van Beuningen, Rotterdam* (Alexandria, Va.: Art Services International, 1994), 18.

36. *Bryan's Dictionary of Painters and Engravers* (London: G. Bell and Sons, 1930), 1:66.

37. John Orrell, *The Quest for Shakespeare's Globe* (Cambridge: Cambridge University Press, 1983), 3–69 (see especially p. 26). One of the two pairs of preliminary drawings for the Long View discussed by Orrell may be found in the Yale Center for the Study of British Art, Paul Mellon Collection. The drawings are known as the "West part of Southwarke, toward Westminster" and the "East part of Southwarke, towards Greenwich." The other pair is housed separately: the "view of west London" is in the John Rylands Library, Manchester, and belonged to Hollar's associate John Evelyn; the other drawing, marked in the design as "London," was owned by Samuel Pepys and may be found in the collection bearing his name at Cambridge. We are grateful to Ralph Alan Cohen for reference to Orrell's study.

38. Parry, *Hollar's England*, 21.

39. Pennington, *A Descriptive Catalogue*, xxxiv.

40. See Katherine S. Van Eerde, *John Ogilby and the Taste of His Times* (Folkestone: Dawson, 1976), 15–47.

41. The painter and etcher Francis Cleyn was born at Rostock and, while still a boy, went to work for Christian IV of Denmark. Sometime before 1620, James I lured him to England to work at the newly established Mortlake tapestry workshop, employment he continued under Charles I. Cleyn supervised the preparation of tapestry designs and took commissions from members of the nobility for ornamental designs for their houses. After the Civil War, Cleyn was employed primarily as a designer of book illustrations.

42. Van Eerde, *John Ogilby*, 40.

43. Arthur M. Hind, *A History of Engraving & Etching from the 15th Century to the Year 1914* (New York: Dover Publications, 1963), 197.

44. Godfrey, *Wenceslaus Hollar*, 138.

45. See George S. Layard, *The Headless Horseman, Pierre Lombart's Engraving: Charles or Cromwell?* (London: Philip Alan & Co., 1922). In addition to commenting on Lombart's skills as an artist, Layard says that Lombart was an opportunist, taking advantage of whatever came his way.

46. Joseph Strutt, *A Biographical Dictionary* (London: J. Davis for R. Faulder, 1785–1786), 2:102–103.

47. Godfrey, *Wenceslaus Hollar*, 15.

48. John Ogilby, *Africa* (London: Tho. Johnson, 1670), sig. c1r.

49. Graham Parry, *The Trophies of Time: English Antiquarians of the Seventeenth Century* (Oxford: Oxford University Press, 1995), 6.

50. Ibid., 3–6.

51. Ibid., 10–11.

52. Anthony Wood, *Fasti Oxonienses* in *Athenae Oxonienses* (London, 1692), as cited in Parry, *Trophies of Time,* 221.

53. Parry, *Trophies of Time,* 222.

54. Ibid., 11.

55. Vertue, *A Description of the Works,* 149.

56. Parry, *Trophies of Time,* 234.

57. Globe, *Peter Stent,* 31.

58. See William Dugdale, *Life, Diary, and Correspondence,* ed. William Hamper (London, 1827).

59. John Aubrey, as quoted in Anthony Powell, *John Aubrey and His Friends* (London: Eyre & Spottiswoode, 1948), 273.

60. Gerald Guinness, comp., *St. Paul's Cathedral* (London: Jackdaw Publications, 1969), broadsheets I–III. Hollar also produced a plate of the Cathedral as it appeared with the spire (P1017).

61. Ibid., broadsheet III.

62. Translation of the text from Parry, *Trophies of Time,* 238.

63. Parry, *Hollar's England,* 23.

64. John E. N. Hearsey, *London and the Great Fire* (London: John Murray, 1965), 155–156.

65. William Dugdale, *The History of St. Paul's Cathedral* (London: Edward Maynard, 1716), xxx.

66. See Godfrey, *Wenceslaus Hollar,* 25–27.

67. Pennington, *A Descriptive Catalogue,* 172: "Plates VI–XX are partly engraved, partly etched, and the etched work seems certainly to be by H." Further, "This map, although under Ogilby's name, may be all that remains of Hollar's great cartographical work on London which he mentions in his petition to the king. . . ."

68. See Katherine S. Van Eerde, *Wenceslaus Hollar: Delineator of His Time* (Charlottesville: University Press of Virginia, 1970), 73.

69. See Pennington, *A Descriptive Catalogue,* 52–61, for descriptions of these plates.

70. *Calendar of State Papers, Domestic, 1668–1669,* as cited in Van Eerde, *Wenceslaus Hollar,* 85.

71. Van Eerde, *Wenceslaus Hollar,* 85. Most of the watercolors are now in the Department of Prints and Drawings of the British Museum.

72. Hind, *History of Engraving,* 258–259.

The Techniques of Etching and Engraving

Julie L. Biggs

Incongruous as it may seem, the delicate etched lines created by Wenceslaus Hollar can be traced back to cave paintings scratched into rock by primitive man. Through the ancient civilizations and beyond the Middle Ages, engraving was used as a form of decoration, but it was not until the fifteenth century that it was recognized as a vehicle for transferring an inked design to paper.

Printmaking is divided into three categories—relief, intaglio, and planographic—which correspond to raised, recessed, and flat printing surfaces. Relief printing is the oldest method, dating back at least to the ninth-century woodcuts of the Chinese. The planographic or lithographic process, invented by the Bavarian Alois Senefelder in 1778, revolutionized printmaking and eventually became the pre-eminent graphic arts process.[1]

Intaglio prints are made from a metal plate—usually copper—that is incised either with tools or with a combination of tools and acid. Because the image is formed from inked channels that lie below the surface of the metal plate, intaglio printing requires great pressure to force the ink out of the recessed areas and onto the paper. An etching or engraving press comprises a rolling-cylinder mechanism—like an old clothes mangle—with a flat metal bed below it that holds the incised plate face up. In the printing process, dampened paper covered with woven felts is placed over the inked plate, and the pressure supplied by the rollers compresses the felts sufficiently to force the paper into contact with the ink lying in the incised lines of the plate. The force of the rollers also presses the paper over the edges of the plate, which produces the characteristic plate mark we associate with intaglio printing.

In engraving, the artist employs a burin, or graver, which is an angled metal tool with a mushroom-shaped handle. The point of the burin is V-shaped and must be very sharp in order to cut out a sliver of metal as it moves through the plate. In the accompanying illustration, we can see

Opposite: Detail of an illustration signed by Pierre Lombart that appeared in John Ogilby's 1654 edition of Virgil and that combines engraving and etching on the same plate.

60

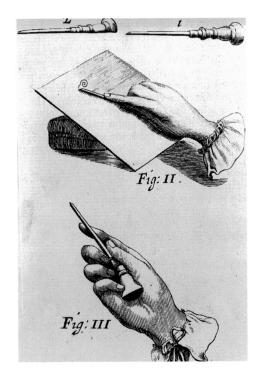

how both plate and burin are angled to facilitate the engraver's progress. Regardless of how sharp it is, however, the graver always leaves a slight ridge, known as the burr, along the sides of the furrow it carves in the metal. The burr can be left as a distinguishing feature that gradually wears down from printing, but the majority of engravers remove it with a scraper.

Many of the earliest engravings, produced between 1450 and 1520, were masterpieces. But, according to Gabor Peterdi, "Within two hundred years of its invention printmaking began to degenerate from creative process to reproductive medium."[2] Italy, the origin of so many innovations in the Renaissance, was also the location for the growth and development of reproductive engraving. Dürer was well known in Italy and artists copied his work; it was Marcantonio Raimondi, more than any other engraver, however, who used the German master's compositions most abundantly and, at times, unscrupulously—sometimes signing his name to an image copied line-for-line from Dürer. Marcantonio developed a close association with Raphael, who recognized the potential of reproduction in the graphic-arts medium; through their collaboration Marcantonio influenced an entire generation of engravers, and ultimately changed the direction of printmaking.[3]

It was not until the beginning of the sixteenth century that a less laborious alternative to engraving was introduced. Etching is the selective corrosion of a metal plate. The copperplate[4] is covered with a dark, acid-resistant coating containing wax, called the ground, that is usually applied to a warm plate so that it is evenly and thinly distributed. In the seventeenth century, the ground was generally blackened by smoking so that the lines the artist drew appeared bright and shiny against the dark ground.[5] The actual engraving agent in etching is the mordant or acid because the lines drawn with the etching needle merely expose the areas to be incised. Therefore, the etcher must anticipate the outcome of the line he produces; when he draws a line, he must visualize it transformed by the action of acid. The prepared plate can have acid poured over it, or it can be immersed in an acid bath. George Vertue, in his description of Hollar's technique, reports that the artist built up a "verge," or wall, of wax around the plate, which functioned as a reservoir for the acid.[6] This was probably a common method until the acid bath was introduced towards the end of the seventeenth century.

Varnish, applied to the plate before exposure to acid, is used to protect the sides and back of the plate and to "stop out." Stopping out is a fundamental part of the etching process; it allows the etcher to arrest the action of the acid on lines that are already bitten to the desired depth and width, while continuing to work other areas. The plate is removed from the acid, washed, and dried; the artist then paints the lines he wishes to stop out with varnish.

Smoking the ground on a plate from William Faithorne,
The Art of Graveing and Etching, *1662.*

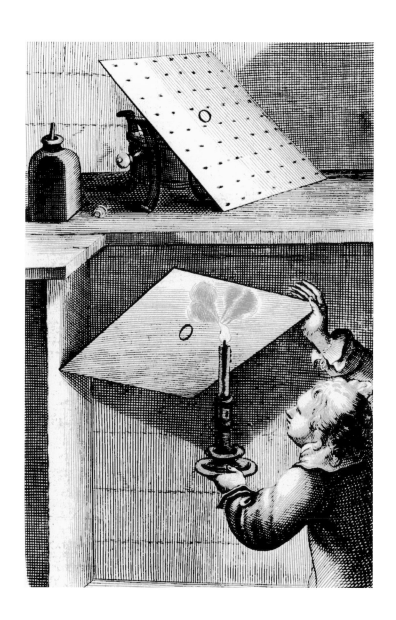

Etching the plate from William Faithorne,
The Art of Graveing and Etching, *1662.*

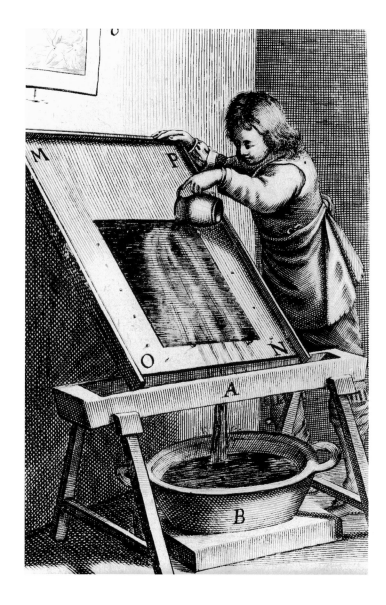

62

A detail of a copy of a Jacques Callot print from his series *Balli di Sfessania* illustrates the difference in lines that have been partially stopped out. The example is crude, but by numerous applications of acid, the technique can achieve remarkably subtle effects.

The choice of acid is not an arbitrary decision in the etching process; indeed, throughout the history of etching, many different combinations have been tested, adopted, and abandoned. Nitric acid and Dutch mordant are now the most commonly used.[7] Nitric acid is extremely efficacious, but its action can produce air bubbles and uneven or overexposed lines. Wenceslaus Hollar evidently used nitric acid; we know this because Vertue's description of Hollar's technique refers to his use of a feather to dispel air bubbles that would otherwise cling to the plate surface and cause uneven biting, known as "foul bite."[8] Mordants are weakly acidic solutions that permit more controlled biting by increasing the time that the plate is exposed to the acid; furthermore, the gentle action of the mordant does not generate air bubbles.

Once the plate is etched, the ground is removed, the plate is inked, and an impression is generally taken. This initial print represents the first state of the etching. The state of a print does not reflect its condition; rather, it is a record of the changes made to a plate over time, by way of corrections and additions. Each successive printing that records a change represents a different state. When the retouching —generally done with a burin—is performed by the original artist while he is creating his image, each printing is called a proof or trial proof; however, in the seventeenth century, and specifically in the case of Hollar, changes in state generally represent alterations to inscriptions and reworking of worn plates, most of which was done after publication.[9]

What makes the techniques of etching and engraving so distinct from each other? Unlike the etcher, whose hand can move in any direction, the engraver must exert steady pressure while pushing the graver or burin into the surface of the metal to form a recessed line; in order to change the direction of his line, he must turn the plate—resting on a pad—with his free hand. The result is a highly defined, regular line that tends to widen towards the middle and taper at either end. We can see the formality and intensity of the engraved line in Pierre Lombart's portrait of Robert Stapleton; overall there is a rich three-dimensional quality to the image. By contrast, the freedom of the etcher's needle is beautifully demonstrated in

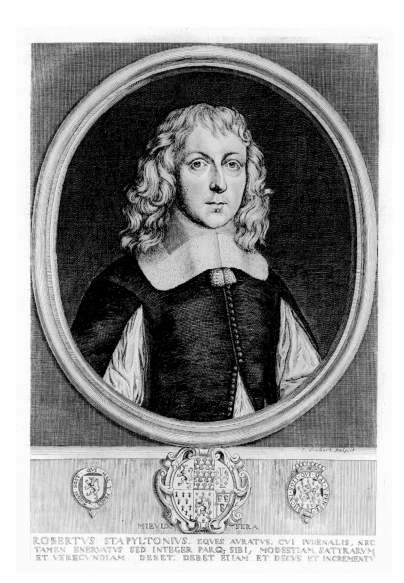

ROBERTVS STAPYLTONIVS. EQVES AVRATVS. CVI IVVENALIS. NEC
TAMEN ENERVATVS SED INTEGER PARQ; SIBI, MODESTIAM SATYRARVM
ET VERECVNDIAM. DEBET: DEBET ETIAM ET DECVS ET INCREMENTV

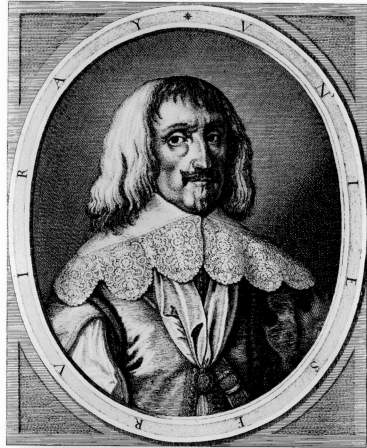

THE RIGHT HONOVRABLE. SIR PHILLIP HERBERT Knight,
Earle of Pembroke & Montgomery, Baron Herbert of Cardiffe & Sherland, Lord
Parr & Rosse of Kendall, Lord Fytz-hugh, Marmyon & Saint Qvyntin. Lord Lieu
tenant of Wyltes. Hampshire & the Ile of Wight, Glamorgan, Monmouth, Breck
nock Carnarvon & Merioneth. Chancellor of the Vniversity of Oxford, Knight
of the moſt noble order of the Garter & one of his Maiᵗⁱᵉˢ moſt honoᵇˡᵉ priuy Councell

S. Antons van dck pinxit. W. Hollar fecit Londini Aᵒ 1642.

Detail of Lombart's engraving of Robert Stapleton.

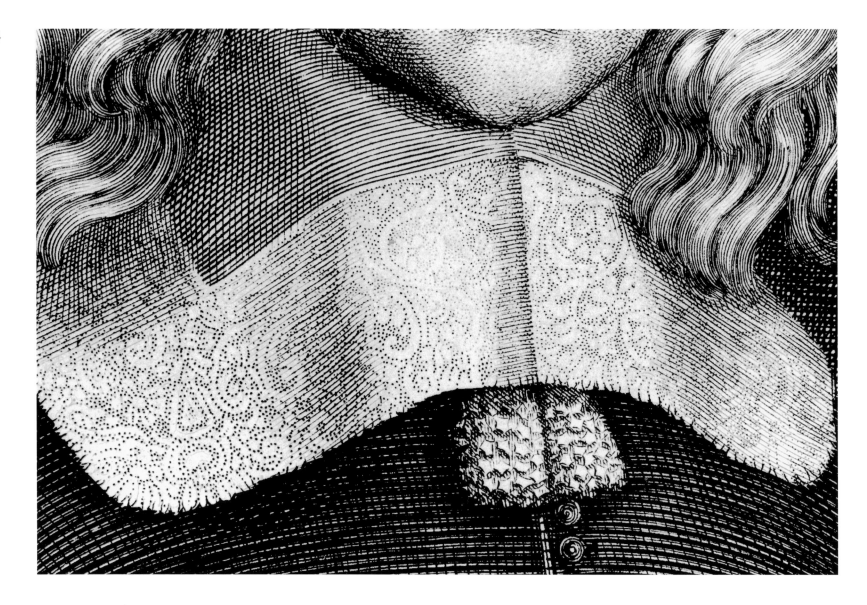

Detail of Hollar's etching of the Earl of Pembroke.

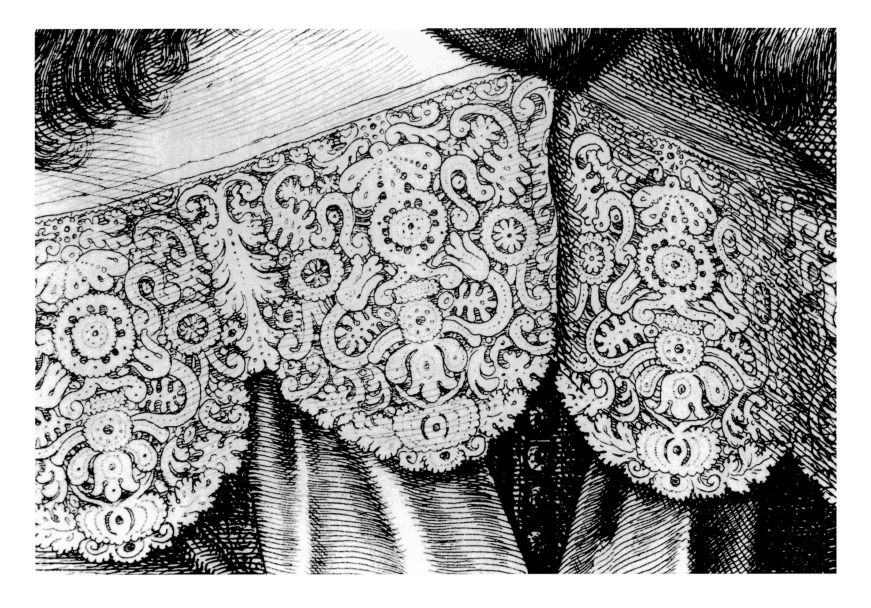

66

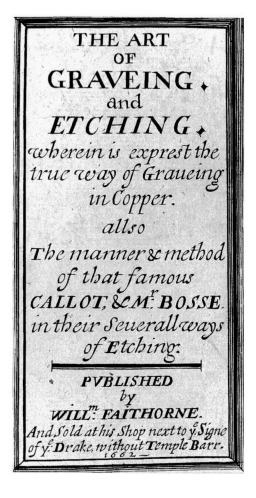

Wenceslaus Hollar's portrait of the Earl of Pembroke. A detail of the lace collar in Hollar's etching displays a flexibility that is akin to drawing. Lombart, on the other hand, had to incise his plate with dots to achieve the texture of the lace.

In the seventeenth century, one could be bled by a physician or could purchase an architectural treatise illustrated with fifty plates for the same price.[10] Maps, prints, illustrated books, pamphlets, broadsides, and copy books were sold by printsellers and at bookshops to a wide market. Significantly, the English papermaking industry, off to a late start, was steadily gathering momentum.[11] Simultaneously, architectural treatises and manuals on drawing and on the principles of art and printmaking were becoming increasingly popular. Many were translations of successful Continental publications: Abraham Bosse's *Traicté des manières de graver* was published in Paris in 1645. William Faithorne recognized the importance of Bosse's work and in 1662 published an abridged English version with additions, commenting in the preface that his *Art of Graveing and Etching* was not "a mear translation." Indeed, it became a seminal work, providing a wealth of practical information that was complemented by Faithorne's own illustrations. Under

the heading, "To the Lovers of this Art," Faithorne claimed that engraving and etching "hath arrived to such an height in these our latter times, as becomes a fit subject for our Kingdomes knowledge and practice."[12] In 1666, Roger L'Estrange published *A book of drawing, limning, washing or colouring of maps and prints and the art of painting or The young-mans time well spent.* The subtitle reveals something of prevailing trends in the seventeenth century, although artistic pursuits were not restricted to men; an entry in Samuel Pepys's Diary from 7 November 1666 reads, "Called at Faythorn's, to buy some prints for my wife to draw by this winter…."[13] Reproductive prints were widely used for drawing studies, but they were also employed as templates for the application of paint—a precursor to modern-day coloring books.[14]

Fortunately, the early modern interest in printmaking and the publications it spawned have preserved the working techniques of many artists. Most seventeenth-century printmakers utilized a ground composed predominantly of wax, mixed with varying quantities of asphaltum and other materials, such as mastic and burgundy pitch.[15] Like recipes for grounds, those for varnishes differed, and the artist could be very particular. Callot had his varnish,

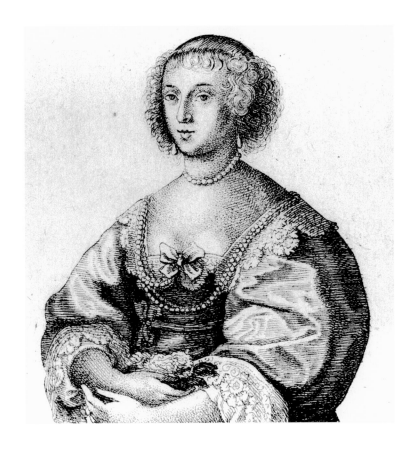

Detail of Lady with Flowers from Wenceslaus Hollar's Ornatus Muliebris Anglicanus *(P1785, state 2).*

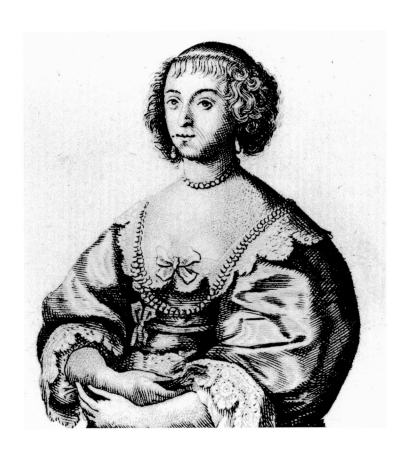

Heavily reworked detail of Lady with Flowers (state 4).

vernice grosso de lignaioly, sent from Italy where it was made by "joyners, who used it to varnish their [wood]work."[16]

In 1669, just seven years after Faithorne's *The Art of Graveing and Etching,* Alexander Browne published his book for "ingenious gentlemen." Browne's folio was not limited to discussions of printmaking techniques but included chapters on painting and limning; his rules on symmetry, proportions, and perspective were beautifully illustrated with full-page engravings. Clearly the author intended to furnish the reader with a solution to every problem.

In the section entitled "The Art of Etching," Browne describes "The way to preserve any Ground, which is laid upon the Plate in Frosty weather." Apparently if the plate was exposed to frost, the ground would "break up" when the mordant was applied to it.

Printmaking developed quintessentially as a reproductive medium; thus, in the seventeenth century, the printer's—and publisher's—aim was to obtain the maximum number of impressions, or "pulls," from the plate. This number varied with the type of metal used for the plate and the printmaker's technique; copper was preferred because the artist could work it with relative ease, and yet it was resilient. Artists could purchase plates already prepared by careful hand-hammering and polishing, which produced a uniform structure in the metal and consequently a superior image. An engraved plate could yield between seven and eight hundred good impressions, but an etched plate—unless it had been heavily bitten—would print no more than a scanty two hundred.[17]

When plates became worn, the printed lines grew faint, sometimes disappearing altogether, and the overall image was patchy and indistinct. Printers and publishers frequently employed artists to rework worn plates so that they could be used again. In the illustrations from Hollar's *Ornatus Muliebris Anglicanus*, we can see the differences between an early impression and a late reprinting. State two was published in 1640 and the reworked state four in 1734. A burin has been used to add shading and definition that probably was

lost from the worn plate, but the retouching is curiously out of place. The delicacy of the etched line has been replaced by the thick contours of an engraver's line; the image has lost its integrity. Intaglio printmakers today have no interest in duplicability. Rather, they tend to capitalize on the limited potential of their plates, and they sign and number each impression so that it is clear how many there are in a particular edition. As a final insurance against the unauthorized re-use of existing plates, printmakers frequently deface their plates by scoring the surface once the print run has been completed.

Engraving and, to a lesser extent, etching declined toward the end of the seventeenth century. Both in terms of predominance and quality, the line processes were simply displaced by the tonal mezzotint that became so popular in England, particularly in portraiture.[18] In one sector of printmaking, however, the engraver and etcher went undeposed: the book trade required the linear processes for detailed illustrations of buildings, maps, and figures, the key word being *detailed*. It was through the printed picture medium that information could be most effectively conveyed. Wenceslaus Hollar's commissions for William Dugdale exemplify this. The polarization of the printing processes con-

tinued and, by the eighteenth century, reproductive prints were common; they were executed with a mixture of etching and engraving and were known as line engravings, to distinguish them from the tonal intaglio images.[19] Printmaking had become a commercial practice, the work of technicians.[20] The graphic arts survived, however, and in the modern era have achieved the status they deserve. As William Blake wrote, "Painting is drawing on canvas, and engraving is drawing on copper, and nothing else, and he who pretends to be either painter or engraver without drawing is an imposter."[21]

Notes

1. Bamber Gascoigne, *How to Identify Prints* (New York: Thames & Hudson, 1986), 1c.

2. Gabor Peterdi, *Printmaking: Methods Old and New*. Revised edition (New York: Macmillan, 1971), 22–23.

3. Arthur M. Hind, *A History of Engraving & Etching from the 15th Century to the Year 1914* (New York: Dover Publications, 1963), 90–97, 118–139.

4. The earliest plates used for etching were made of iron, but they were replaced by copper around 1520. Brass and, to a lesser extent, pewter were also used. William M. Ivins, Jr., *How Prints Look* (Boston: Beacon Press, 1958), 84.

5. Alexander Browne describes a white ground that contained wax, rosin, and *venice cervis*. This substituted for the smoking of the plate; the idea was to approximate the effect of printed lines on paper by making the etched lines dark against the metal plate. See Alexander Browne, *Ars Pictoria* (London: J. Redmayne, 1669), 100.

6. George Vertue, *Note Books I. Walpole Society Publications*, XVIII (1930), 112.

7. Peterdi, *Printmaking*, 145. Dutch mordant is a saturated solution of potassium chlorate and hydrochloric acid in a 9:1 ratio.

8. Arthur M. Hind, "Studies in English Engraving, V: Wenceslaus Hollar." *The Connoisseur*, XCII:386 (October 1933), 219.

9. Richard Pennington, *A Descriptive Catalogue of the Etched Work of Wenceslaus Hollar, 1607–1677* (Cambridge: Cambridge University Press, 1982), xv.

10. Leona Rostenberg, *English Publishers in the Graphic Arts, 1599–1700* (New York: Burt Franklin, 1963), ix, 93.

11. Paulette Long, ed., *Papermaking Art and Craft* (Washington, D.C.: Library of Congress, 1968), 25.

12. William Faithorne, *The Art of Graveing and Etching* (London: Will^m: Faithorne, 1662), A2^r.

13. *Extracts from the Diaries and Correspondence of John Evelyn and Samuel Pepys*, with notes by Howard C. Levis (London: Ellis, 1915), 65.

14. Roger L'Estrange, *A book of drawing, limning, washing. . .* (London: M. Simmons for Thomas Jenner, 1666), 17.

15. A refined and partially solidified grade of Burgundy turpentine, the balsam obtained from *Pinus maritinus*, or the European pine.

16. Faithorne, *The Art of Graveing*, 1–2.

17. William Gilpin, *An Essay on Prints*, 5th edition (London: A. Strahan for T. Cadell and W. Davies, 1802), 35.

18. Richard Godfrey, *Printmaking in Britain* (New York: New York University Press, 1978), 27–29.

19. There is a wealth of confusion about line engraving and the prints so classified. Bamber Gascoigne's explanation appears here and is the most comprehensive and unambiguous.

20. Gascoigne, *How to Identify Prints*, 147–148.

21. Ivins, *How Prints Look*, 147.

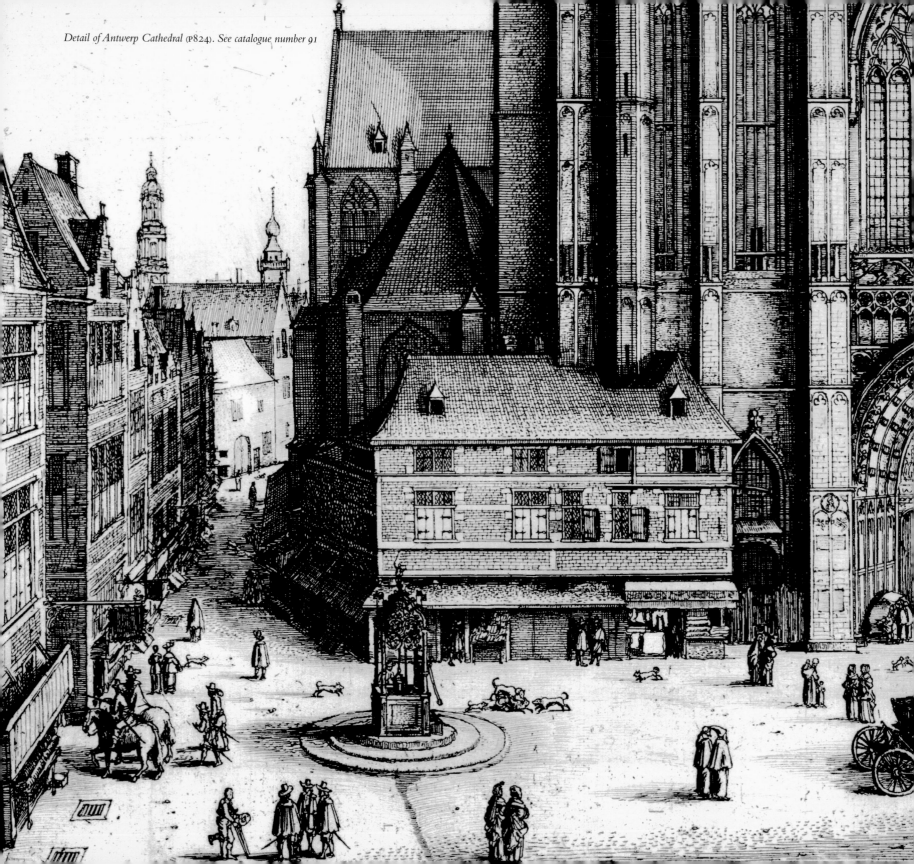

Catalogue of the Exhibition

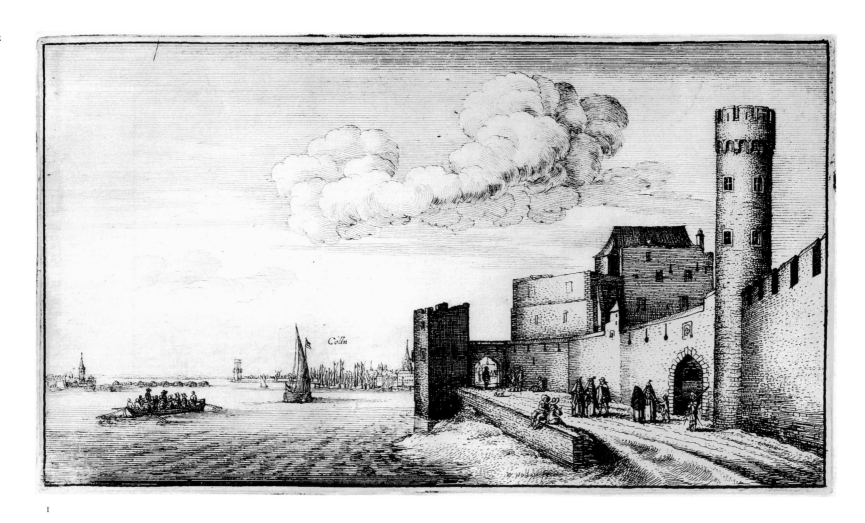

Cölln

I

1 Cologne
Cölln
P720 (state 2)
Signed: W. Hollar fecit
92 x 170; 95 x 173*
From the set *AMOENISSIMI, ALIQVOT*
Locorum in diversis Provincijs iacentium
Prospectvs. London, 1643–1644.

2 Mülheim
P725 (state 2)
Unsigned
91 x 169
From the set *AMOENISSIMI, ALIQVOT*
Locorum in diversis Provincijs iacentium
Prospectvs. London, 1643–1644.

Hollar built up a huge archive of draw-
ings throughout his life and often etched
plates using sketches he had made many
years earlier. His view of Cologne was
etched from a drawing he made in 1630;
he met the Earl of Arundel there in
1636. Hollar's view of Mülheim also
must have been based on a sketch from
his early travels in Germany.

3 Wenceslaus Hollar, self-portrait
P1420 (state 2)
Unsigned, but dated 1647
128 x 92
Illustrated on page 14.

4 Strasbourg Cathedral
P893a
Signed: W[h]ollar fe: 1630
129 x 99
Illustrated on page 15.

5 Strasbourg Cathedral
TVRRIS ET ÆDES ECCLESIÆ
CATHEDRALIS ARGENTINENSIS
a Wenceslao Hollar Bohemo, primo ad
vivum delineata, et aqua forti æri
insculpta, A.° 1630. denuoque facta
Antuerpiæ, A.° 1645.
P892
Signed: W. Hollar fecit 1645
218 x 177; 224 x 184
Illustrated on page 16.

**Measurements are given in millimeters and follow Pennington's format: the measurements of the printed image, followed by the measurements of the plate. If a print has been cropped inside the platemark, only one set of measurements is given. Our measurements frequently differ from Pennington's. The practice of cutting plates, denoted by a change in state, can result in substantial alterations in size. The size of prints always varies slightly because each piece of paper dampened for printing will shrink differently from another. In addition, many prints have been treated by restorers and have gained a few millimeters as a result.*

7

6 An old man and a girl, after Hülsman
P1556
Signed: I. Hulsman inu:/ WHollar fec:
1635
91 X 120

7 A man's head, after Screta
P1643
Signed: C. Screta Boh: inv:/1627/
WHollar fe: 1635
76 x 66; 78 x 67
*The gift of Jean Miller in memory of
Geoffrey Ashton.*

Hollar's etching is based on a drawing
made by his countryman and friend
Karel Screta in 1627. It is likely that
Hollar and Screta left Prague at about
the same time and met again in Stuttgart
in 1627–1628.

8 Greenwich
Grænwich
P977 (state 4)
Two plates
Signed: W. Hollar fecit
London: Printed and sould by Peter Stent
146 x 835
Illustrated on pages 18–19.

9 Richmond
P1058
Signed: W. Hollar fecit, 1638
109 X 332

Although this version of Richmond
is often referred to as a copy, both
Pennington and Godfrey consider it a
copy by Hollar himself. There are minor
differences between it and the original
version: no period after "RICHMOND,"
no comma after "Hollar," no cogs on the
wheel of the crane, the design on the
ship's flag changed to a large "G." The
well-dressed people in the foregound
have been identified as Charles I, Queen
Henrietta Maria, and their two sons.

10 The fleets off Deal
VERA ET EXACTA DELINEATIO
CLASSIVM. . . in Freto Brittãnico iuxta
Dealam Castrum. . . Anno 1640
P548
Two plates
Signed: W. Hollar fecit
Left plate: 148 x 505;
Right plate: 147 x 506
Illustrated on the cover.

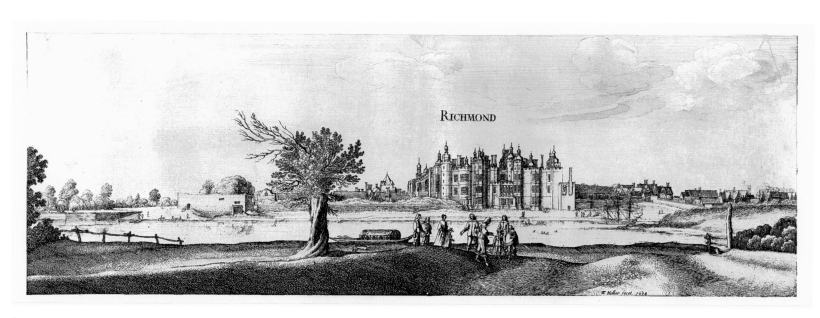

DAT GRATIAM HVMILIBVS.

God hates the proud, the humble are his care
Hence hils are barren. Valleies fruitful are,

11

12

11 Humility
DAT GRATIAM HVMILIBVS
P195A
Unsigned
91 x 60; 95 x 62
Frontispiece to Henry Peacham,
The Valley of Varietie. London: M. P. for
Iames Becket, 1638.

This simple, unsigned emblematic fron-
tispiece was Hollar's first work for a
London stationer, to whom he probably
was introduced by Henry Peacham.

12 Clidamas
CLIDAMAS, or, The Sicilian Tale, by I.S.
P2655 (state 2)
Signed: W: Hollar, fecit
120 x 71; 123 x 75
Title page to I. S., *Clidamas*. LONDON:
Printed by Th: Paine, and are to be sould
by Iohn Cowper, 1639.

Although it is one of his earliest
works for the London printers, it seems
implausible that Hollar forgot to write
all of the letters in reverse on his plate.
It was not an uncommon mistake, but
Hollar's interest in and attention to
lettering should have prevented him
from making such an error.

13 Frederick Henry, Prince of Orange
 P1687
 Unsigned
 254 x 184; 257 x 188
 From Jean Puget de La Serre, *Histoire de
 l'entree de la reyne mere du roy tres-chrestien
 dans les Provinces unies des Pays Bas.*
 A Londre: Iean Raworth pour George
 Thomason & Octauian Pullen, 1639.

14 Death's arrest
 P199
 Unsigned
 104 x 95; 116 x 99
 Illustration to "Ultima" in Isaac
 Ambrose, *The second birth. Prima et ultima.*
 London: John Okes for Samuel Brown,
 [1640].

"Death's arrest" is one of eight designs
by Hollar for *The second birth* by Isaac
Ambrose, a Presbyterian minister who
was a popular preacher and whose works
were widely read. The figure of Death
anticipates the Dance of Death series
that would follow a decade later.

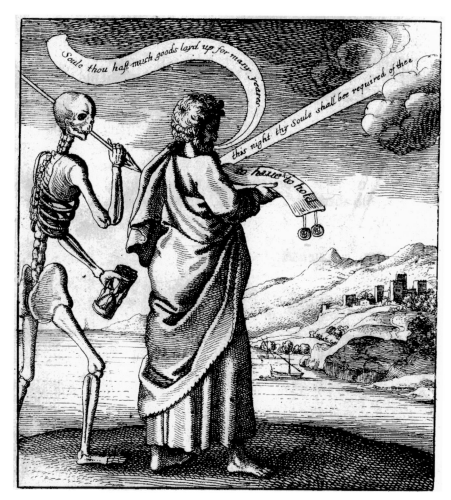

14

15 The Academy of Love
 P2673
 Signed: W. Hollar fecit
 135 X 106
 Title page to John Johnson, *The Academy
 of Love*. London: Printed for Humphrey
 Blunden, 1641.
 Illustrated on page 21.

16 EN SURCULUS ARBOR
 P480 (state 1)
 Signed in image: W. Hollar fecit Londini
 1641
 250 X 182

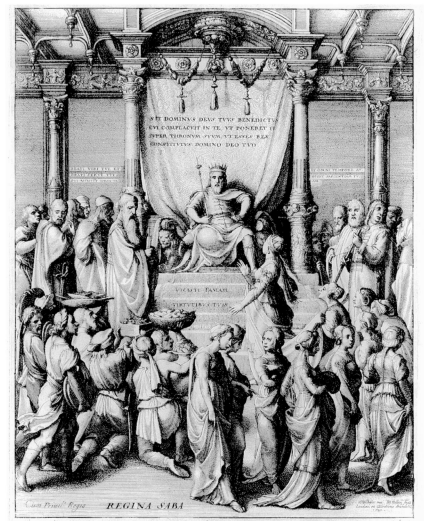

17 Solomon and the Queen of Sheba
MULTITVDO SAPIENTIVM EST
SANITAS ORBIS TERRARVM, ET REX
SAPI/ens Populi stabilimentum, Sap:6
P74 (state 2)
Signed: Cum Priuil: Regis REGINA
SABA/H. Holbein inu: W. Hollar,
fecit./Londini, ex
Collectione Arundeliã/1642
234 x 179; 248 x 184
Purchased on the Elizabeth Niemyer
Acquisitions Fund.

Hollar's etching after Holbein was copied
from a colored miniature on vellum that
was once in Arundel's possession and is
now in the Windsor Castle collection.

18 Thomas Howard, Earl of Arundel
ILLVSTRIS:^us & EXCELLENT:^mus
D:^mus DOMINVS THOMAS
HOWARD, COMES ARVNDELIÆ
& SVRRIÆ primus Comes &
summus Marescallus Angliæ, etc:. . .
et ejusdem Regis A° 1639
Contra Scotos Supremus & Generalis
Militiae Dux
P1353 (state 3)
Signed: Ant: van Dyck Eques pinxit,
WHollar fecit 1646
268 x 193

19 Lady with feather fan
P1778A (state 1)
Signed: W. Hollar fecit./1
122 x 70; 134 x 72
From *ORNATVS MVLIEBRIS*
Anglicanus or THE SEVERALL Habits
of English Women. . .Wenceslaus Hollar,
Bohemus fecit. Londini, A°:1640.

The *Ornatus Muliebris Anglicanus* is
probably Hollar's best-known series
of costume plates. Many of the images
were reprinted continuously through
the beginning of the nineteenth century.

20 Lady with muff, standing on two steps
P1784 (state 1)
Unsigned, but dated 1639
122 x 73; 134 x 74
From *ORNATVS MVLIEBRIS*
Anglicanus or THE SEVERALL Habits
of English Women. . .Wenceslaus Hollar,
Bohemus fecit. Londini, A°:1640.

21 Lady with flowers
P1785 (state 2)
Signed: Hollar, fecit 1638
123 x 73; 134 x 74
From *ORNATVS MVLIEBRIS*
Anglicanus or THE SEVERALL Habits
of English Women. . .Wenceslaus Hollar,
Bohemus fecit. Londini, A°:1640.
Detail illustrated on page 67.

22 Lady with flowers
P1785 (state 4)
Signed: Hollar, fecit 1638
122 x 73; 134 x 74
From *ORNATVS MVLIEBRIS Anglicanus*
or THE SEVERALL Habits of English
Women. . . Sold by H: Overton at the
White Horse without Newgate, 1734.
Detail illustrated on page 67.

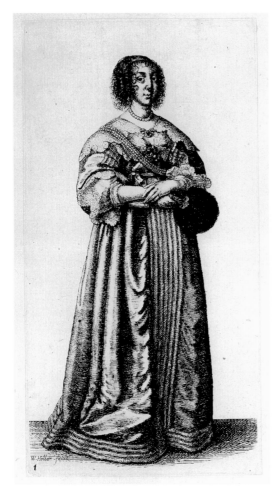

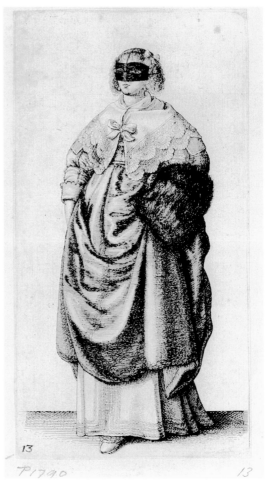

19

24

23 Lady with fan and mirror
P1787 (state 1)
Signed: W. Hollar inu: 1639/10
122 x 70; 133 x 71
From *ORNATVS MVLIEBRIS Anglicanus
or THE SEVERALL Habits of English
Women. . .Wenceslaus Hollar, Bohemus fecit.*
Londini, A°:1640.
Illustrated on page 23.

24 Lady with mask and muff
P1790 (state 1)
Unsigned /13
122 x 72; 134 x 72
From *ORNATVS MVLIEBRIS Anglicanus
or THE SEVERALL Habits of English
Women. . .Wenceslaus Hollar, Bohemus fecit.*
Londini, A°:1640.

Hollar was particularly fascinated with
fur muffs. His later depictions of them
would establish muffs as one of his most
successful and unique subjects.

25 Lady with ruff and muff
P1795 (state 1)
Signed: Hollar/fecit. 1640/18
128 x 70; 133 x 70
From *ORNATVS MVLIEBRIS Anglicanus
or THE SEVERALL Habits of English
Women. . .Wenceslaus Hollar, Bohemus fecit.*
Londini, A°:1640.

26 Ciuis Pragensis filia
P1811 (state 2)
Signed: W. Hollar fec: 1643
90 x 58; 93 x 60
From *AVLA VENERIS sive VARIETAS
Fœminini Sexus, diversarum Europæ
Nationum. . .* Londini, A° 1644.

27 William of Orange and Princess Mary
P1324 (state 2) and P1307 (state 2)
Signed: W: Hollar fecit, 1641.
Are to be sould by Tho: Bankes in
Black-friers atop of Bridewell staires
87 x 53 and 71 x 53 (ovals only)

28 William of Orange
WILLIAM of Nassau, borne Prince
of Orange;
P1522
Signed: W: Hollar, fecit Londini, 1641
132 x 99 (oval only)

29 William of Orange
WILLIAM OF NASSAV etc: BORNE
Prince of Orange
P1523 (state 2)
Signed (not by Hollar): W: Hollar fecit
cum priuil: Regis;
211 x 147

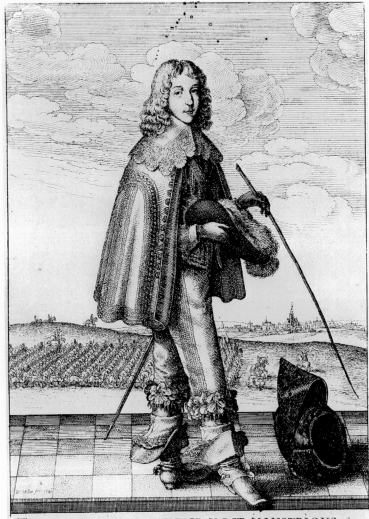

THE PORTRAICTVRE OF THE MOST ILLVSTRIOVS &
Noble, William of Naſſau Prince of Orange, &c. borne 1627
& maried 23 May, 1641.
Are to be ſold, by Tho: Ienner at the old Exhange.

30

30 William of Orange
THE PORTRAICTVRE OF THE MOST
ILLVSTRIOVS & Noble, William of
Nassau Prince of Orange. . . borne 1627
& maried 23 May, 1641
P1524 (state 1)
Signed: W. Hollar fec. 1641
Are to be sold by Tho: Ienner at the
old Exhange
191 x 125; 197 x 132

In portraits such as this one it is apparent
that Hollar paid as much attention to the
details of men's clothing as to women's.

31 Earl of Pembroke
THE RIGHT HONOVRABLE SIR
PHILLIP HERBERT Knight, Earle of
Pembroke & Montgomery. . .
P1481 (state 1)
Signed: Sr. Antoni van dyk pinxit/
W. Hollar fecit Londini A°. 1642
269 x 187; 271 x 191
Illustrated on page 63.

32 SPRING
P610 (state 4)
Signed: W: Hollar inuentor et fecit
Londini, A° 1641
243 x 175; 247 x 180
Illustrated on page 25.

33 SVMMER
P611 (state 2)
Signed: W. Hollar inu:1641
242 x 173; 248 x 178

34 AVTVMNE
P612 (state 2)
Signed: W. Hollar inu:/1641
244 x 176

35 WINTER
P613 (state 2)
Signed: W. Hollar inu: 1641
246 x 176; 253 x 182

36 Henrietta Maria
P1537 (state 1)
Signed: Ant: van dyck pinxit, W. Hollar
fecit,/1641.
156 x 116
Illustrated on page 25.

37 Winter
P617 (state 3)
Unsigned
162 x 121; 180 x 127
From Edward Benlowes, *Theophila,
or loves sacrifice.* London: By R. N.,
sold by Henry Seile and Humphrey
Moseley, 1652.

38 Parliamentary mercies
The Earle of Strafford. . .beheaded on
the Tower-hill;
Sr. Francis Windebank, Sr. Iohn Finch,
the Lord Digbie. . .fly for their lives
beyond sea
P491A, no. 4 a & b (state 1)
Unsigned
123 x 95; 128 x 100
From John Vicars, *A Sight of ye trans-
actions of these latter yeares.* [London]:
Sould by Thomas Ienner, [1646].
Illustrated on page 26.

39 Parliamentary mercies
No legend [Execution of the Earl
of Strafford]
P491A, no. 4a (state 3)
Unsigned
95 x 60; 100 x 64
From John Vicars, *Former ages never heard
of.* London: By M.S. for Tho. Jenner, 1660.
Illustrated on page 27.

40 Parliamentary mercies
The King Escapes out of Oxford in
a disguised maner
P491A, no. 4b (state 2)
Unsigned
62 x 95; 65 x 100
From John Vicars, *Former ages never heard
of.* London: By M.S. for Tho. Jenner, 1656.
Illustrated on page 27.

41　Sea fight at Cadiz 1656
P1244
Unsigned
79 x 117
From *A Book of the continuation of forreign passages.* London: By M.S. for Thomas Jenner, 1657.

42　Sea fight at Santa Cruz 1657
P1244
Unsigned
80 x 119; 83 x 124
From *A Further Narrative of the Passages of these times in the Common-wealth of ENGLAND.* [London]: By M.S. for Thomas Jenner, [1658].

Catalogue nos. 41 and 42 are the same image. In no. 41, letterpress text above the etching identifies the sea fight as "the late sucesse. . .against the King of Spains West-india Fleet, in its return to Cadiz. . . Octob: 4, 1656." In no. 42, the same image is used to illustrate "A Narrative of the Action at Sancta Cruz."

43　Tears of Ireland
The Lord Blany forced to ride 14 Miles; M^r Dauenant and his Wife bound in their Chaires.
P491B, no. 5 a & b (state 1)
Unsigned
125 x 70; 127 x 74
From James Cranford, *The teares of Ireland.* London: A.N. for Iohn Rothwell, 1642.

44　Tears of Ireland
The Preestes & Iesuites anointe the Rebells; They do usually mangell there dead Carcases
P491B, no. 9 a & b (state 2)
Unsigned
126 x 68; 129 x 70
From *Ireland, or a booke.* London: for Iohn Rothwell, 1647.

45　Map of England and view of Prague with scenes of the beginning of the Civil War
P543
Unsigned
291 x 346; 292 x 353
Frontispiece to John Rushworth, *Historical Collections,* vol. 1. London: Tho. Newcomb for George Thomason, 1659.
Illustrated on page 28.

46　The Royal Exchange
BYRSA LONDINENSIS, vulgo The Royall Exchange of London
P1036 (state 2)
Signed: W: Hollar fecit Londini, Anno 1644
288 x 389

47　Execution of Strafford
THE TRUE MANER OF THE EXECUTION OF THOMAS EARLE OF STRAFFORD, LORD Lieutenant of Ireland, vpon Tower hill, the 12th of May, 1641
P552 (state 2)
Signed: WH
184 x 256

Here Hollar demonstrates his great talent for capturing the spectacular moment while seeming to keep a physical and, perhaps, psychological distance. The Earl of Strafford was Charles I's agent, adviser, and, to Puritans, henchman in secular matters. After Strafford's defeat by Scottish rebels, Charles used him as a scapegoat and agreed to Strafford's execution to pacify parliament. German text was added to state 2, and the etching was used in several Continental publications.

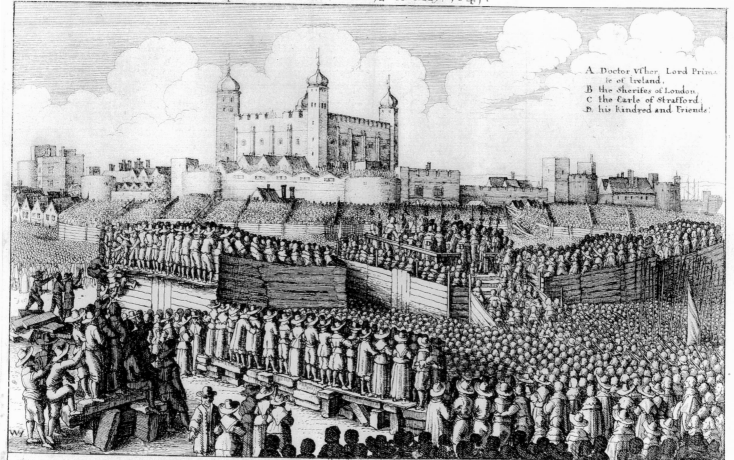

THE TRUE MANER OF THE EXECUTION OF THOMAS EARLE OF STRAFFORD, LORD Lieutenant of Ireland, vpon Towerhill, the 12th of May, 1641.

A Doctor Vſher, Lord Prima te of Ireland,
B the Sherifes of London,
C the Earle of Strafford,
D his kindred and Friends.

Execution des Grafen Thomæ von Stafford Statthalters in Irland auf dē Tawers platz in Londen 12 Maj 1641.
A. Doct. Uſher Primat in Irland.
B. Rahts Herren von Londen.
C. Der Graf uon Stafford.
D. Seine anverwanten vnd freünde.

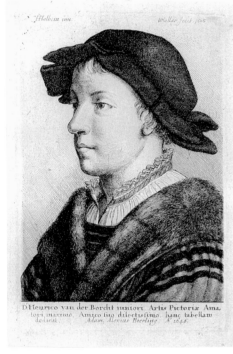

50

48 Anne Boleyn
ANNA BVLLEN REGINA ANGLIAE
Henrici VIIIui Vxor. . . decollata,
Londini, 19 Maij,
Aº.: 1536
P1342
Signed: H. Holbein delineauit; W: Hollar
fecit, ex Collectione Arundeliana,
Aº. 1649
129 x 101
*The gift of Mrs. John Farr Simmons in honor
of Elizabeth Niemyer.*

49 Jane Seymour
IOHANNA SEYMOVR REGINA,
HENRICI VIII: Regis Angliae Vxor 3ª.
Edwardi 6ᵗⁱ. Mater
P1427
Signed: HHolbein pinxit. W: Hollar fecit
aqua forti, ex Collectione Arundeliana,
1648
131 x 105

50 Young man, after Holbein
P1543
Signed: HHolbein inu: WHollar fecit, 1646.
133 x 89; 135 x 90

The Holbein portrait that Hollar copied
is now in the Louvre. While Holbein did
not complete the young man's costume,
Hollar did.

51 Hans von Zürich
HANS VON ZVRCH GOLTSHMIDT
P1411
Signed: Hans holbein 1532/ WHollar
fecit, 1647
ex collectione Arundeliana
200 x 131

52 Young woman with a scarf on her head,
after Bonsignori
P1613
Signed: Monsignor inu:/ W.Hollar fec
1645
93 x 71

53 Young woman with hair in rolls,
 after Bonsignori
 P1614
 Signed: Monsignor inu/ W.Hollar fec:
 1645
 100 X 72
 The gift of Mrs. Eudora L. Richardson
 in honor of Elizabeth Niemyer.

54 Head of a young girl, after Parmigianino
 P1623
 Signed: F Parm:/inu:/ W.Hollar/fecit
 70 X 52; 73 X 54
 The gift of Mr. and Mrs. Alexander Jeffries
 in honor of Elizabeth Niemyer.

 Hollar etched this delicate portrait
 after the Italian mannerist painter,
 Parmigianino, who was also an etcher.
 There is no date or dedication to this
 print, but it may have been copied from
 a drawing in the Arundel collection.
 The Earl had a large number of works
 by Parmigianino and Correggio,
 a fellow Emilian painter.

55 Petrarch's Laura, after Giorgione
 P1540
 Signed: W.Hollar fecit/1646
 97 X 67

56 Caricature, after Leonardo
 P1587 (state 2)
 Signed: Leonardo da Vinci/ inu:/
 W Hollar, fecit
 115 X 77

57 Caricature, after Leonardo
 P1592 (state 2)
 Signed: Leonardo da Vinci inu:/
 W.Hollar fecit
 75 X 104; 75 X 105

54

88

58

60

58 Young negro
P2003 (state 2?)
Unsigned
59 x 42
*Purchased on the Elizabeth Niemyer
Acquisitions Fund.*

59 Young negress (profile)
P2006
Signed: W.H: fecit/1645
58 x 43; 62 x 46
*Purchased on the Elizabeth Niemyer
Acquisitions Fund.*

60 Young negress
P2007
Signed: W.Hollar fecit/Antverpiae A°
1645
74 x 57

These etchings were probably done from
life. The Countess of Arundel took an
African page from Italy to Arundel
House in 1632, and he may still have
been there when Hollar arrived in 1636.
African servants were not uncommon,
so Hollar could well have sketched the
young girl in either Antwerp or London.

61 American Indian
Vnus Americanus ex virginia, Aetat: 23.
P2009 (state 2)
Signed: W:Hollar ad viuum/delin: et
fecit, 1645
102 x 77; 104 x 78
The gift of Barbara Fahs Charles.

62 Turk's head
P2010 (state 3)
Signed: W.Hollar ad viuum deli:/Londini
1637 et fecit
An[tverpiae]/A° 1645
76 x 61

63 Garden of Eden (Dance of Death)
Quia audasti vocem. . .res &c: Gen: 3:
P233 (state 3)
Border P233A (state 2): Democritus and
Heraclitus
Print unsigned; Border signed (not by
Hollar): Ab.a Dvpenbecke inu. A Paris
Chez N. Pitau. . .W. Hollar fecit
Print: 74 x 53; 76 x 55
Border: 114 x 90; 115 x 93

64 Paradise Lost (Dance of Death)
Emisit eum Dominus. . .sumptus est.
Gen: 3
P234 (state 2)
Border 233A (state 3): Democritus and
Heraclitus
Print unsigned; Border signed (not by
Hollar): Ab.a Dvpenbecke inu. A Paris
Chez N. Pitau. . .W. Hollar fecit
Print: 74 x 53; 76 x 54
Border: 114 x 89; 115 x 93

65 Empress (Dance of Death)
Gradientes in superbia. . .humiliære Dan. 4
P238 (state 2)
Border 233A (state 3): Democritus and
Heraclitus
Print unsigned; Border signed (not by
Hollar): Ab.a Dvpenbecke inu. A Paris
Chez N. Pitau. . .W. Hollar fecit
Print: 73 x 50; 76 x 53
Border: 114 x 89; 115 x 92

66 Queen (Dance of Death)
Mulieres opulentæ. . .vos conturbemini,
/Isai. 32.
P239 (state 2)
Border 233A (state 3): Democritus and
Heraclitus
Print unsigned; Border signed (not by
Hollar): Ab.a Dvpenbecke inu. A Paris
Chez N. Pitau. . .W. Hollar fecit
Print: 72 x 53; 76 x 54
Border: 113 x 89; 115 x 93

67 Duke (Dance of Death)
Princeps induetur. . .potentium, Ezech: 7
P241 (state 2)
Border P233B: Minerva and Hercules
Print signed: WH; Border signed: Ab: a
Diepenbecke inu: W: Hollar fecit, 1651.
Print: 72 x 52; 76 x 54
Border: 113 x 87; 117 x 93
Illustrated on page 30.

68 Nobleman (Dance of Death)
Cum fortis armatus. . .confidebat, Luc. 11.
P250 (state 2)
Border P233C: Time and Eternity
Print unsigned; Border signed: Ab a
Diepenbecke inu:W: Hollar fecit,
Print: 72 x 53; 75 x 54
Border: 113 x 89; 115 x 93

This etching is entitled the Knight
by Pennington. In Holbein's original,
however, the same image is a Nobleman.
Holbein's Knight is a different figure
and is not included in Hollar's series.

69 Bridal Pair (Dance of Death)
Me & te sola Mors separabit, Ruth, 2.
P252 (state 2)
Border P233A (state 3): Democritus and
Heraclitus
Print signed (not by Hollar): HB.i.W.H.;
Border signed (not by Hollar): Ab. a
Dvpenbecke inu. A Paris Chez N. Pitau
. . .W. Hollar fecit
Print: 71 x 53; 75 x 55
Border: 113 x 90; 115 x 93
Illustrated on page 31.

70 Merchant (Dance of Death)
Qui congregat. . .ad laqueos Mortis
Proverb: 21
P254 (state 2)
Border 233C: Time and Eternity
Print signed (not by Hollar): HB.i.WH.;
Border signed: Ab a Diepenbecke inu:
W: Hollar fecit.
Print: 72 x 53; 74 x 55
Border: 113 x 89; 115 x 93

71 Gamesters (Dance of Death)
Quid prodest. . .patiatur, Matth, 16,
P258 (state 2)
Border 233C: Time and Eternity
Print signed (not by Hollar): HB.i.WH.;
Border signed: Ab a Diepenbecke inu:
W: Hollar fecit,
Print: 73 x 53; 74 x 55
Border: 113 x 89; 115 x 92

72 Old man (Dance of Death)
Spiritus meus. . .sepulchrum, Iob, 17.
P259 (state 2)
Border 233B: Minerva and Hercules
Print signed (not by Hollar): HB.i.WH;
Border signed: Ab: a Diepenbecke inu:
W: Hollar fecit, 1651.
Print: 73 x 53; 75 x 54
Border: 113 x 88; 116 x 93

73 Old Woman (Dance of Death)
Melior est Mors quam Vita. Eccle: 30.
P260 (state 2)
Border 233B: Minerva and Hercules
Print signed (not by Hollar): HB.i.WH;
Border signed: Ab: a Diepenbecke inu:
W: Hollar fecit, 1651.
Print: 72 x 53; 76 x 54
Border: 113 x 88; 116 x 93

74 Death's Coat of Arms (Dance of Death)
MORTALIVM NOBILITAS/ Memorare
nouissima. . .peccabis. Eccle; 7
P262 (state 2)
Border: 233A (state 3): Democritus and
Heraclitus
Print signed (not by Hollar): HB.i.WH;
Border signed (not by Hollar): Ab. a
Dvpenbecke inu. A Paris Chez N. Pitau
. . .W. Hollar fecit
Print: 74 x 53; 76 x 55
Border: 113 x 89; 115 x 93

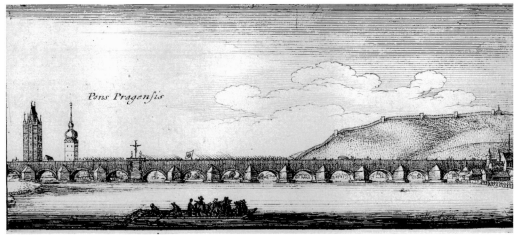

75

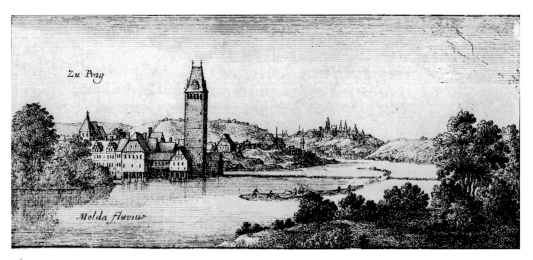

76

75 Prague
Pons Pragensis
P 748 (state 1)
Signed: W Hollar fecit
59 x 138

76 Prague
Zu Prag
P 776 (state 2?)
Signed: [Wenceslaus Hollar]
58 x 132

During Hollar's travels between 1627
and 1636, he drew numerous views of
places he visited. He saw Prague for the
last time on his journey with the Earl of
Arundel in 1636.

77 Ober-Wesel
P 875
Unsigned
57 x 133; 62 x 137

78 Sebins
P 779
Signed: WHollar fecit
56 x 134; 61 x 137

ILLVSTRISSIMÆ ET EXCELLENTISSIMÆ DNE. DOMINÆ ALATHEÆ TAL-
bot Arundeliæ & Surriæ Comitisse, etc: hanc tabellam olim ab Alberto Durero ad viuum depic-
tam ianq in Collectione Arundeliana conseruatam, & a Wenceslao Hollar Bohemo Aqua forti æri
insculptam humillime offert et dedicat. Adam Alexius Bierling Antuerpiæ Anno 1646.

79 Wenceslaus Hollar
WENCESLAUS HOLLAR,
Gentilhomme ne a Prage
P1419 (state 2)
Signed: Ie. Meyssens pinxit et excudit.
158 X 111; 161 X 115
From Jean Meyssens, *IMAGE DE
DIVERS HOMMES D'ESPRIT
SUBLIME.* A Anvers: Iean Meyssens, 1649.
See frontispiece.

80 Adrian van Venne
ADRIAEN VAN VENNE/Natieff de
Delft
P1514 (state 4)
Signed: A: van Veen pinxit, W:Hollar fecit,
I. Meyssens excudit.
162 X 111; 165 X 116
From Sebastian Resta, *THE TRUE
EFFIGIES OF THE MOST EMINENT
PAINTERS, AND OTHER FAMOUS
ARTISTS.* [London], Printed 1694.

81 Dürer the elder
1497 · ALBRECHT · THVRER ·
DER · ELTER · VI ID · ALT · 70 JOR
P1389 (state 2)
Signed: Albertus Durerus pinxit,
W:Hollar fecit.
202 X 158
*Purchased on the Elizabeth Niemyer
Acquisitions Fund.*

82 Woman with coiled hair, after Dürer
P1536 (state 1)
Unsigned
237 X 175

Hollar was deeply influenced by the
work of Albrecht Dürer from his earliest
exposure to Dürer's works in Prague.
While he copied the work of other
artists for many reasons, Hollar seems
to have been drawn to Dürer in particu-
lar for his rendering of detail through
the intaglio medium. This etching was
printed in Antwerp in 1646 and was
dedicated to Alathea Talbot, the
Countess of Arundel.

83 Richard Weston, Earl of Portland
PER ILLUSTRIS DOMINVS
HIERONYMVS WESTONIVS, COMES
PORTLANDIÆ / HEYLANDIÆq, etc,
P1483 (state 2?)
Signed: Antonius van Dyck pinxit/
W:Hollar fecit, aqua forti, 1645.
Ioannes Meyssens excudit
239 X 186

84 Margaret Lemon, after Van Dyck
MARGVERITE LEMON ANGLOISE
P1456 (state 2)
Signed: Anton: van Dyck Eqves pinxit,
Henr. vander Borcht excudit. W:Hollar
fecit, 1646
255 X 176; 260 X 181

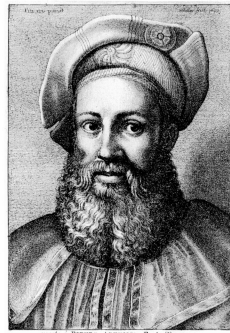

85

85 Pietro Aretino
questo è PIETRO ARETINO
Poeta Tosco
P1346 (state 2)
Signed: Titianus pinxit WHollar fecit,
1647
199 X 133
The gift of Werner and Karen
Gundersheimer.

Titian painted two portraits of his
friend, the poet Pietro Aretino, both of
which Hollar etched. Aretino's derisive
wit was legendary and so feared that
he became wealthy on the bribes sent
to appease him. Aretino's malice is less
than evident in this flamboyant and
jocular portrait.

86 Seated huntress, after Van Avont
P276 (state 3)
Signed (not by Hollar): P. Pontius et
W. Hollar faciebant/ P: van Avont inu:
207 X 154
Illustrated on page 32.

87 Sleeping huntress, after Van Avont
P277 (state 2)
Signed in image: W. Hollar fecit;
P. Pontius sculp. added outside border
(not by Hollar)
146 X 210

88 Six hounds, after Van Avont
P2047
Signed: WHollar fecit, 1646
131 X 204
Illustrated on page 33.

89 The bridge over the waterfall
P1208 (state 1)
Signed: Iacques van Artois pinxit,
W: Hollar fecit, 1648. Antuerpiae.
Petrus van Avont excudit.
147 X 207

90 Cottage on a hill
P1205 (state 2)
Signed: Iacques van Artois pinxit,
W. Hollar fecit, C. Galle Excudit,
144 X 219

91 Antwerp Cathedral
ANTVERPIENS TVRRIS ECCLESIÆ
CATHEDRALIS, BEATISSIMÆ
VIRGINIS MARIÆ DEI-PARÆ,
P824 (state 2)
Signed: Wenceslaus Hollar delineauit,
et fecit, 1649
473 X 329

This etching was produced a few years
after Hollar's Strasbourg Cathedral (P892),
illustrated on page 16. It is one of Hollar's
true masterpieces and demonstrates his
great talent for capturing architectural
detail. Like the Strasbourg Cathedral
etching, it suggests the importance of
the Cathedral in the daily life of the city.

92 Peace of Munster
Eÿgentlycke Afbeeldinghe ende maniere,
van de publicatie van den Peys tusschen
syne Maÿesteyt den Coninck van
Spagnien, ende de Heeren Staten
Generael van de Vereenich Nederlanden
. . .5 Iuny 1648
P561
Signed: F. v. Wyngaerdt excudit/
W. Hollar fecit
214 X 333 ; 218 X 337

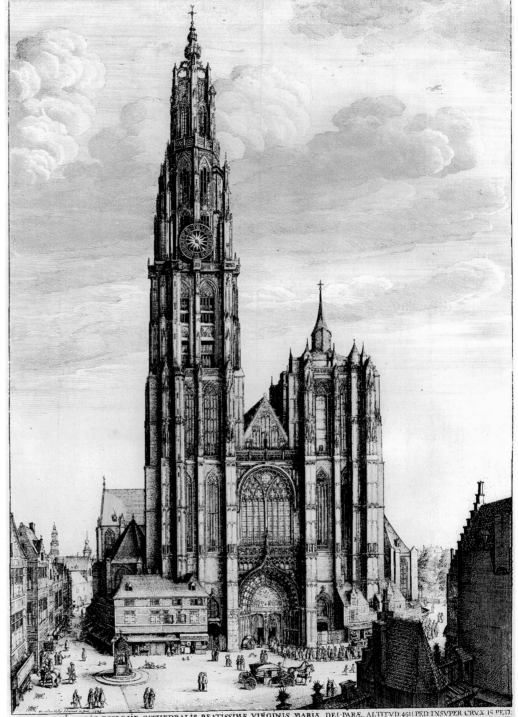

97

96

93 A recumbent lion, after Dürer
P2094 (state 2)
Signed: Alb: Durer pinxit,/ W. Hollar fecit
ex Collectione/Arundeliana, 1645
88 X 125

94 A lion standing, after Dürer
P2095 (state 2)
Signed: Albertus Durer inu: WHollar
fecit ex Collectione Arundeliana/C. Galle
100 X 152

95 A stag lying, after Dürer
P2092 (state 2)
Signed: Albertus Dürer, delin:/
W. Hollar fecit, 1649
83 X 113; 87 X 115

96 A stag lying, after Dürer
P2093 (state 2)
Signed: Albertus Durerus pinxit,/
W:Hollar fecit, Ex Collectione
Arundeliana,/1649
85 X 114; 87 X 116

97 Donkey, after Bassano
P2090
Signed: I. Bassan delin:/ W: Hollar fecit,
1649
77 x 113; 80 x 115

The donkey in this etching is probably
taken from Jacopo Bassano's painting
Ripos Durante La Fuga in Egitto. Hollar's
identification of Bassano as "delin." sug-
gests that he may have copied from a
drawing, rather than from a painting,
which Hollar usually attributed to the
painter as "pinxit."

98 Dead mole
P2106
Signed: W:Hollar fecit, 1646
52 x 127; 70 x 138

99 Dutch warships
Naves Bellicae Hollandicae
P1268 (state 2)
Signed: W Hollar fec: 1647
143 x 232

100 The Brussels packet
de Heu van Brussels
P1269 (state 2)
Unsigned
145 x 235

101 Two warships under sail
P1259
Signed (not by Hollar): W Hollar fecit
176 x 95 (includes lettering)

102 A sea fight
P1257
Signed (not by Hollar): Wentzel Hollar
fecit
175 x 93

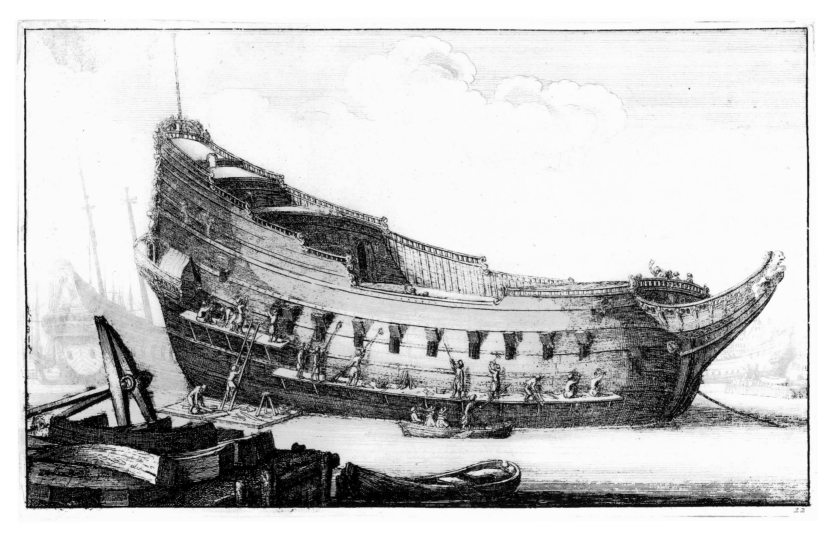

103 Fitting out a hull
P1264 (state 2)
Signed: WHollar fecit 1647
138 X 232; 143 X 235
The gift of Commander and Mrs.
Walter C. Avery.

Fitting Out a Hull is one of Hollar's
most appealing subjects, originally exe-
cuted as a drawing (Hollareum, Prague).
Some of the lines on the left border and
around the anchor are unusually dark
and thick; the incised lines must have
held more ink in these parts. Other
impressions of this etching show the
same line variations. Perhaps Hollar did
not apply his stop-out varnish properly.
In any case, it is a curious and uncharac-
teristic inconsistency.

104 London. The Long View
P1014 (state 1)
Signed: Wenceslaus Hollar delineauit
et fecit Londini et Antverpiae, 1647
Prostant AMSTELODAMI apud
Cornelium Danckers..., An°. 1647
Section a: 465 x 192
Section b: 461 x 389
Section c: 461 x 391
Section e: 462 x 389
Section f: 463 x 397
Section g: 464 x 198

The Folger lacks the center section of
the Long View.

105 London and Westminster
THE PROSPECT OF LONDON and
WESTMINSTER Taken from Lambeth,
by, W: Hollar
P1013 (state 2)
Section a: 315 x 386
Section b: 315 x 386
Section c: 315 x 386
Section d: 313 x 383

106 View of Lambeth from Whitehall Stairs
P912
Unsigned
90 x 167

107 St. Mary Overy
S: Marie Ouer's in Southwarke
P910
Signed: WHollar fec: 1647
144 X 253; 150 X 258

108 Alexis
P290 (state 1)
Signed: Fr: Cleyn inu: W. Hollar fecit,
1652
290 x 193; 298 x 196
From Virgil, *The works...Translated...*
and illustrated with annotations by John
Ogilby. London: Thomas Warren for the
author, 1654.
Illustrated on page 37.

109 Stock breeding
P298 (state 3)
Signed: F. Cleyn inv. W. Hollar fecit
296 x 190
From Virgil, *The works...Translated...*
and illustrated with annotations by John
Ogilby. London: Thomas Warren for the
author, 1654.

111

110 Menalcas, Damoetus and Palaemon
P290A
Signed: F. Cleyn inv/ PLombart scupsit
Londini
292 x 193; 295 x 199
From Virgil, *The works. . .Translated. . .*
and illustrated with annotations by John
Ogilby. London: Thomas Warren for the
author, 1654.
Illustrated on page 37.

111 Venus brings Aeneas his weapons
P321 (state 6)
Signed: F. Cleyn inv./W. Hollar fecit,
1653.
297 x 194; 304 x 201
From Virgil, *The works. . .*Translated into
English verse; by Mr. Dryden. Adorn'd
with a hundred sculptures. London:
Printed for Jacob Tonson, 1697.

When Hollar's plates were used to
illustrate Dryden's translation of Virgil,
Aeneas's nose became a Roman one,
changed with an engraver's burin as
a compliment to King William III.

112 St. Paul's, South side
ECCLESIÆ CATHEDRALIS S^{ti}.
PAVLI, A MERIDIE PROSPECTVS
P1018 (state 1)
Signed: W. Hollar delin: et sculp:
193 X 375; 203 X 382
From William Dugdale, *The History of
St. Pauls Cathedral in London*. London:
by Tho. Warren, 1658.

113 St. Paul's, North side
ECCLESIÆ CATHEDRALIS S. PAVLI
A SEPTENTRIONE PROSPECTVS
P1019 (state 1)
Signed: W. Hollar delineavit et sculp:
Londini, 1656
179 X 370; 200 X 375
From William Dugdale, *The History of
St. Pauls Cathedral in London*. London:
by Tho. Warren, 1658.

114 St. Paul's, The Nave
NAVIS ECCLESIÆ CATHEDRALIS
S. PAVLI, PROSPECTVS INTERIOR
P1025 (state 1)
Signed: Wenceslaus Hollar Bohemus,
hujus Ecclesiæ (quotidie casum expec-
tantis) delineator et olim admirator,
memoriam sic preseruauit, A° 1658
395 X 348; 403 X 354

115 Canterbury Cathedral: plan
Areæ Cantuariensis Ecclesiæ Ichnographia
P962 (state 1)
Signed: Tho: Iohson delin, W. Hollar fecit
[204] x 319; [211] x 322
From Sir William Dugdale, *Monasticon
Anglicanum sive pandectae Coenobiorum...*
London: Richard Hodgkinsonne, 1655.

116 William Dugdale
GULIELMUS DUGDALE Ætatis.
50. A° MDCLVI
P1392 (state 2)
Signed: Wenceslaus Hollar delin:
et sculpsit
254 X 167; 259 X 173
Frontispiece to Sir William Dugdale,
The Antiquities of Warwickshire Illustrated.
London: Thomas Warren, 1656.
Illustrated on page 42.

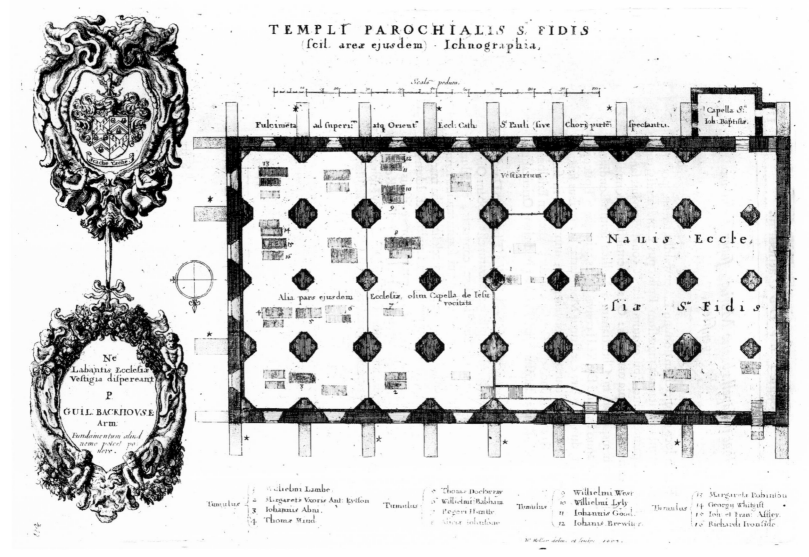

TEMPLI PAROCHIALIS S. FIDIS
(scil. areæ ejusdem) · Ichnographia,

Scala pedum.

Fulcimeta ad superi. atq Orienti Eccl: Cath. S. Pauli (five Chori) ptei spectantu

Capella S. Ioh: Baptistæ.

Vestiarium.

Nauis Eccle.

Alia pars ejusdem

Ecclesiæ, olim Capella de Iesu vocitata.

siæ S. Fidis

Ne Labantis Ecclesiæ Vestigia dispereant P GUIL. BACKHOVSE Arm: Fundamentum aliud nemo potest ponere.

Tumulus			Tumulus		Tumulus		Tumulus	
1	Willielmi Lambe.			Thomæ Dockwray		Willielmi Weer		Margaretæ Robinson
2	Margaretæ Vxoris Ant: Eyston			Willielmi Babham	10	Willielmi Lyly	14	Georgij Whitgift
3	Iohannis Abni.			Rogeri Hornby	11	Iohannis Good.	15	Ioh: et Fran: Aftley
4	Thomæ Mind.			Aluer: Iohnson	12	Iohannis Brewster	16	Richardi Ironside

W. Hollar delin: et sculp: 1663.

117 Plan of the crypt of St. Paul's
TEMPLI PAROCHIALIS S^{tæ}. FIDIS. . .
Ichnographia
P1029 (state 1)
Signed: W. Hollar delin: et sculp: 1657
199 X 297; 202 X 302
From Sir William Dugdale, *The History
of St. Pauls Cathedral in London.* London:
by Tho. Warren, 1658.

Plans such as this one of the crypt of
St. Paul's were a significant part of the
visual documentation Hollar supplied
for Dugdale's publications, most notably
the *Monasticon Anglicanum.*

118 Interior of the crypt of St. Paul's
ECCLESIÆ PAROCHIALIS S^{tæ} FIDIS
PROSPECTVS INTERIOR,
P1030 (state 1)
Signed: W. Hollar delin: et sculp:
195 X 337; 199 X 345
From Sir William Dugdale, *The History
of St. Pauls Cathedral in London.* London:
by Tho. Warren, 1658.
Illustrated on page 45.

119 Coventry
The Prospect of COVENTRE from
Warwick roade, on the south side of
the Cittye
P970 (state 1)
Signed: W. Hollar fecit,
141 X 292; 145 X 296
From Sir William Dugdale, *The
Antiquities of Warwickshire Illustrated.*
London: Thomas Warren, 1656.

120 Coventry
The ground plott of COVENTRE
P969 (state 1)
Signed: W. Hollar fecit,
167 X 221; 169 X 224
From Sir William Dugdale, *The
Antiquities of Warwickshire Illustrated.*
London: Thomas Warren, 1656.

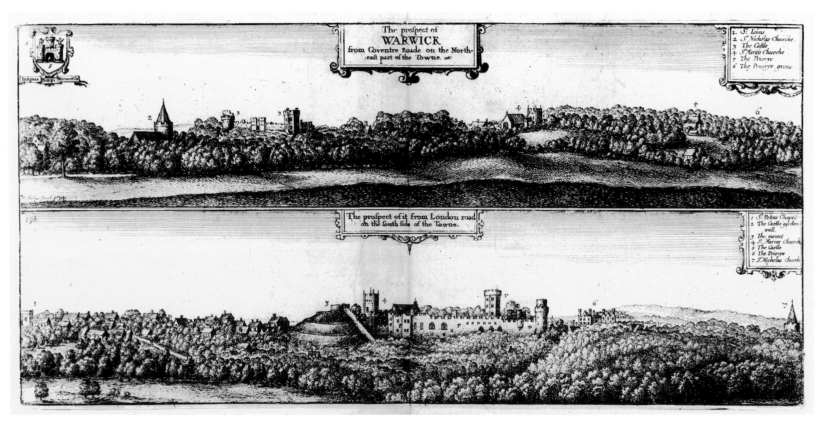

The prospect of
WARWICK
from Coventre Roade on the North-
east part of the Towne.

Insignia Burgi Warwicen?

1. S.t Ioìns
2. S.t Nicholas Churche
3. The Castle
4. S.t Maries Churche
5. The Priorye
6. The Priorye groue

The prospect of it from London road
on the South side of the Towne.

1. S.t Peters Chapell
2. The Castle garden
 wall
3. The mount
4. S.t Maries Church
5. The Castle
6. The Priorye
7. S.t Nicholas Church

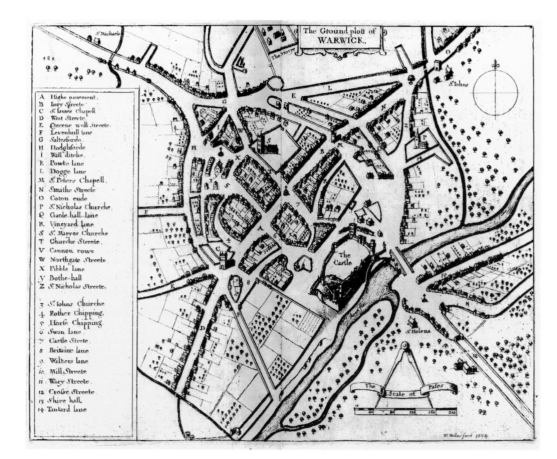

121 Warwick

The prospect of WARWICK from Coventre
Roade on the Northeast part of the Towne
P1070 (state 2)
Signed: W. Hollar fecit. 1654
141 X 291; 145 X 298
From Sir William Dugdale, *The Antiquities
of Warwickshire Illustrated*. London: Thomas
Warren, 1656.

122 Warwick

The Ground plott of WARWICK
P1069 (state 1)
Signed: W. Hollar fecit 1654
178 X 221; 181 X 223
From Sir William Dugdale, *The Antiquities
of Warwickshire Illustrated*. London: Thomas
Warren, 1656.

These two plates of Warwick (printed on
the same page) and the two of Coventry—
only four of the 183 Hollar etched for
Dugdale's *Warwickshire*—demonstrate how
valuable his meticulous attention to detail
can be for the historian. In his prospects,
he preserved a terrain that has changed
considerably over the past three hundred
years, and in the maps he recorded the loca-
tions of buildings, streets, and other land-
marks. His etchings permit us to visualize
parts of Warwickshire as they were only a
few decades after Shakespeare lived there.

122

P. ADAM SCHALIGER A GERMAN, MANDARIN OF Yͤ FIRST ORDER.

125

123 Jerusalem
VNIVERSI TEMPLI HIEROSOLYMI-
TANI ORTHOGRAPHIA . . .
DISSECTI TEMPLI SALOMONIS
ORTHOGRAPHIA
P1134
Signed: W: Hollar fecit aqua forti, Ætat:50.
Anno 1657
392 X 522; 397 X 532
From *Biblia Sacra polyglotta. . . Edidit
Brianus Waltonus* [vol. I]. London:
Thomas Roycroft, 1657.

124 Emperor of China
The Supreame MONARCH of the
CHINA-TARTARIAN Empire,
P1377 (state 3)
Signed: W. Hollar fecit
292 X 208; 304 X 217
From John Nieuhof, *An Embassy from the
East India Company. . .to the Grand Tartar
Cham. . .Englished. . .by John Ogilby.*
London: Ptd. by the Author, 1673.

125 Adam Schaliger
P. ADAM SCHALIGER A GERMAN,
MANDARIN OF Yᵉ FIRST ORDER.
P1501 (state 1)
Signed: WH
294 x 205; 308 x 212
From John Nieuhof, *An Embassy from the
East India Company. . .to the Grand Tartar
Cham. . .Englished. . .by John Ogilby.*
London: Ptd. for the Author, 1673.

Ogilby's translation of Nieuhof's
Embassy was first published in 1669 and
was reprinted in 1673. The plates were
copied by Hollar and others from those
in Nieuhof's original edition of 1665;
Hollar signed only fourteen of the etch-
ings, although he probably had a hand in
more. Adam Schaliger, or Johann Adam
Schall von Bell (1591–1660), was a Jesuit
missionary to China.

126 Persepolis
RVINES of PERSÆPOLIS
P1140 (state 2)
Signed: W: Hollar fecit 1663
255 x 325; 266 x 336
From Sir Thomas Herbert, *Some years
travels into divers parts of Africa and Asia.*
London: by J. Best for A. Crook, 1665.

127 London
LONDON/ London the glory of Great
Britaines Ile/ Behold her Landschip
here, and tru pourfile
P1012 (state 1)
Unsigned
210 x 313

128 London after the Fire
A MAP or GROVNDPLOT
of the Citty of London,
and the Suburbes thereof
P1004 (state 2)
Signed: W. Hollar fecit 1666
Sould by Iohn Overton at the White
horse, 1666
269 x 348
Illustrated on page 46.

129 St. Paul's, West side
ECCLESIÆ CATHEDRALIS. Sᵗⁱ PAVLI,
AB OCCIDENTE PROSPECTVS
P1020 (state 2)
Signed: W. Hollar delin. et sculp:
219 x 255; 227 x 268
From Sir William Dugdale, *The History
of St. Pauls Cathedral in London.* London:
by Tho. Warren, 1653.
Illustrated on page 43.

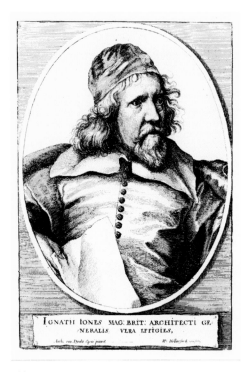

130

130 Inigo Jones
IGNATII IONES MAG: BRIT:
ARCHITECTI GENERALIS,
VERA EFFIGIES
P1428 (state 1)
Signed: Anth: van Dycke Eqves pinxit,
W: Hollar fecit, aqua forti
200 x 133; 205 x 136
Frontispiece to Inigo Jones, *The most notable antiquity of Great Britain. . . called Stone-Heng.* London: by James Flesher, 1655.

Inigo Jones and Hollar were probably introduced by Arundel. Jones was the pre-eminent English architect of his time; he was also a painter, an etcher, and a designer of masques. Hollar has copied Van Dyck's portrait closely.

131 St. Paul's burning (Lex ignea)
P1028 (state 2)
Signed: W. Hollar fecit. A° 1666
61 x 100; 64 x 103
Title page vignette in William Sancroft, *Lex Ignea. . .A Sermon preach'd before the King, Octob. 10. 1666.* London: for Timothy Garthwait, 1666.

132 St. Paul's burning (Lex ignea)
P1028 (state 4)
Signature barely legible
(probably inadequately erased)
62 x 100; 65 x 103
Title page vignette in [Richard Allestree], *The Causes of the Decay of Christian piety.* London: by R. Norton for Robert Pawlett, 1683.

These two images of St. Paul's in flames demonstrate how much an image can change in twenty years and be changed by hands other than the artist's. State 4 has been greatly reworked, and Hollar's signature has been nearly obliterated. Neither image shows the portico burning, a detail that Hollar could not have witnessed.

132

136

133 Bramber Castle
The Ruins of Bramber Castle in Sussex
P951 (state 2)
Unsigned
81 x 131; 86 x 135

134 Isle of Wight
Wight in:
P952 (state 1)
Unsigned
79 x 131

135 Shoreham
P953 (state 1)
Signed: W. Hollar fecit 1645
81 x 132

136 Prospect of the lower part of Tangier
Prospect of y^e lower part of Tangier,
from the hill West of White-hall
P1190 (state 2)
Signed: W: Hollar delin:
116 x 212

137 Prospect of York Castle
Prospect of Yorke Castle at Tangier,
from ye Strand, and the North-West
P1191 (state 2)
Signed: W: Hollar delin: et sculps
125 X 216

Hollar's etchings of Tangier bear a
resemblance to his English views in their
general composition but are devoid of
any suggestion of fondness for the ter-
rain. They do provide, however, a valuable
record of the English fortifications.

138 The lion and the mouse
P340 (state 2)
Signed: W. Hollar fecit,
233 X 169; 256 X 173
From *The fables of Aesop paraphras'd in
verse. . . 2d ed.* By John Ogilby. London:
by Thomas Roycroft for the author,
1668.

Hollar's etchings for Ogilby's edition
of Aesop are often cited, and deservingly
so, for their depictions of animals in
fashionable attire; their subject matter
is varied, however, and they may be
studied for Hollar's depictions of interi-
ors and for his treatment of landscape.

141

139 The crab and its mother
P397 (state 1)
Signed: WHollar fecit 1666
246 x 196; 283 x 205
From *Aesopics: or a second collection of
fables. . .* by John Ogilby. London: by
Thomas Roycroft for the author, 1668.
Illustrated on page 49.

140 The fox and the weasel
P364A (state 1)
Unsigned
146 x 94
From *The fables of Aesop. . . Paraphras'd in
verse. . .the 3d ed. . .By John Ogilby.*
London: by the Author, 1673.

141 Goats, sheep, and mole
P2084
Signed: F. Barlow inu: WHollar fecit,
145 x 206

142 Wolves, foxes, and weasel
P2086
Signed: F. Barlow inu: W.Hollar fecit,
1662
145 x 204

143 Fox Hunting
FOX HVNTING
P2040
Signed (not by Hollar): W Hollar sculp
163 x 218; 169 x 227
From *A Sett of Prints of Hunting,*
Hawking, and Fishing. . .invented by
Francis Barlow. Etched by W: Hollar.
London: Sould by Iohn Overton, 1671.

Francis Barlow was a young contempo-
rary of Hollar, but his style was more
animated and spontaneous. He was
the first English etcher of significance.
The majority of Barlow's prints are of
animals, and his depictions of sporting
subjects established an important tradi-
tion in England. Barlow's drawings were
copied by many other printmakers.
Hollar's etchings after Barlow seem to
strike a balance between Hollar's own
sedate style and Barlow's exuberance.
The prints of hunting, hawking, and
fishing included plates assigned to
Hollar, but the attributions are ambigu-
ous. "Fox Hunting" clearly was not
etched by Hollar, but the inscription
that was added says that Hollar incised
the plate. Perhaps such images were
more marketable if passed off as Hollar's.

. FOX HVNTING .

With Eger Hounds, the Fox is hard pursu'd . | Theire noble chase, and shew'd them Princely Sport
Till him they Earth, whose Subtile shifts renew'd | Whose Death the Cuntrey pleases as the Court .

143

144 Lincoln Cathedral from the East
ORIENTALIS ECCLESIAE
LINCOLNIENSIS FACIES
P994 (state 3)
Signed: W: Hollar Regiae Maj^tis
Scenographus delineavit et sculpsit,
275 x 358; 282 x 367
From Sir William Dugdale, *Monasticon anglicanum. . .* [vol. 3] London: Richard Hodgkinson, 1673.
Illustrated on page 51.

145 Insignia of the Garter
P2639 (state 2)
Signed: Wenceslaus Hollar delineauit et sculpsit, 1666.
296 x 368; 300 x 370
From Elias Ashmole, *THE INSTITU-TION, Laws & Ceremonies of the most NOBLE ORDER OF THE GARTER.* London: by J. Macock, 1672.
The gift of Mrs. H. Dunscombe Colt.

146 Wollaton Hall
WOLLATON HALL
P1085
Signed: R: Hall delineavit.
W: Hollar sculp:
273 x 357; 283 x 362
From Robert Thoroton, *The antiquities of Nottinghamshire.* London: by Robert White, 1677.

Pennington says, "This famous building, so often illustrated, was, Thoroton records, constructed of stone 'brought from Ancaster in Lincolnshire by the people of those parts who then fetch'd coles from Wollaton which they had for their labour.'" Thoroton's work was the last folio volume for which Hollar etched plates, some of which he did not complete before he died. The volume was published the year of his death.

WOLLATON HALL.

These two Coats of Armes, are over the Dore at Wollaton Hall.

R. Hall delineavit. W. Hollar sculp.

Page 223

148

Illustrated on page 48.

147 Propositions Concerning the Map of
LONDON and WESTMINSTER &c:
which is in hand by Wentsel Hollar
Etched prospectus, [1660]
With signed receipt: I acknowledge to
have received of S.ʳ Edward Walker the
Summe of 20 Shill[ing]es upon the
Conditions aforesaid. Wenceslaus Hollar.
26 Jul. 1660
103 X 110; 106 X 115
Illustrated on page 48.

148 The Crucifixion
P82
Signed: Iacobus Palma inu: W. Hollar fecit
131 X 80; 136 X 84
From *The Office of the Holy Week...*
Translated out of French. Paris: by the
Widow Chrestien, 1670.

Hollar's illustrations for this volume, and
this etching of the Crucifixion in partic-
ular, are very suggestive of a sympathy to
Catholicism. Both John Aubrey and
John Evelyn state that Hollar died a
Catholic, apparently having converted
during his years in Antwerp.

149 Thomas Hobbes
Vera & Viva Effigies
THOMAE HOBBES
Malmesburiensis.
P1417 (state 3)
Signature erased
225 x 168; 230 x 171
On the broadside *Memorable sayings of
Mr. Hobbes in his Books and at the Table*
[London, 1680].

John Aubrey reports that Peter Stent,
who commissioned this portrait of
the controversial philosopher, Thomas
Hobbes, refused either to accept it or
to pay Hollar for it; he believed it was
a poor likeness.

Glossary of Terms

aq., aqua forti
acid, especially nitric acid; it denotes the plate has been etched.

asphaltum
a transparent, brown color made by dissolving an asphalt resin in linseed oil. Asphalts are extremely acid-resistant. They were used in the embalming of Egyptian mummies and as a color in oil paints until their aging problems became known.

bite
the corrosive action of mordants and acids on the metal plate.

del., delin., delineavit
indicates whose drawing was copied to produce the printed image.

exc., excudit
generally denotes the publisher, but it can also refer to the artist who "made" the plate.

feathering
the dispersal of air bubbles produced by the action of nitric acid on copper and zinc plates using a feather or a brush.

fec., fecit
indicates the artist responsible for creating the image on a plate: the engraver or etcher.

imp., impressit
printed; in the majority of cases by the intaglio roller method.

impression
every paper that is run through the press becomes an impression. When the plate is not inked, a "blind" impression is produced.

inc., incidit
incised; specifically engraved.

inking
the preparation of the incised plate with ink. It is first applied with a roller or cloth dauber, and sometimes the plate is warmed beforehand to facilitate the distribution of the ink into the grooves. The plate is carefully wiped to clean the surface, leaving the ink in the recessed areas.

in., inv., invt., invenit, inventor
invented or inventor; denotes the original artist whose image is being reproduced.

mastic
a resin extracted from the tree, *Pistachia lentiscus*, that is found in the Mediterranean. Apart from being an ingredient in etching grounds, it was used as early as the sixteenth century for setting mosaics, and, in the nineteenth century, as a picture varnish.

mezzotint
the first of the tonal intaglio processes; it was invented by Ludwig von Siegen in the 1640s and mimicked in print the chiaroscuro effects produced in painting that were popular in the seventeenth century. The fundamental difference between mezzotint and engraving is that the artist works from dark to light, using a crescent-shaped tool called a rocker to indent the surface on the plate with minute pits. The rough surface prints a dark, velvety black, and is burnished and scraped to create lighter tones. Also called *manière noire* and *manière anglais*.

pinx., pinxt., pinxit
indicates whose painting was reproduced in the printed image.

sculp., sculpsit
carved, i.e. engraved, although it was inaccurately used on plates that combined engraving and etching.

Bibliography

Aubrey, John. *Brief Lives.* Edited by Oliver Lawson Dick. London: Secker and Warburg, 1949.

Bridson, Gavin D. R., and Geoffrey Wakeman. *Printmaking & Printing: a Bibliographical Guide to Artistic and Industrial Techniques in Britain, 1750–1900.* Oxford: Plough Press; Williamsburg: Bookpress, 1984.

Brown, Christopher. *Van Dyck.* New York: Cornell University Press, 1982.

Brown, Jonathan. *Kings & Connoisseurs: Collecting Art in Seventeenth-Century Europe.* Princeton: Princeton University Press, 1995.

Burgers, Jacqueline. *Wenceslaus Hollar: Seventeenth-Century Prints from the Museum Boymans-van Beuningen, Rotterdam.* Alexandria, VA: Art Services International, 1994.

Cook, G. H. *Old S. Paul's Cathedral: A Lost Glory of Medieval London.* London: Phoenix House Ltd., 1955.

Denkstein, Vladimir. *Hollar Drawings.* London: Orbis Publishing, 1979.

Dugdale, William. *Life, Diary, and Correspondence.* Edited by William Hamper. London: Harding, Lepard and Co., 1827.

Evelyn, John. *Diary.* Edited by E. S. de Beer. London: Clarendon Press, 1955.

Faithorne, William. *The Art of Graveing and Etching.* London: William Faithorne, 1662.

Five Centuries of Map Printing. Edited by David Woodward. The Kenneth Nebenzahl, Jr., Lectures in the History of Cartography at the Newberry Library. Chicago: University of Chicago Press, 1975.

Gascoigne, Bamber. *How to Identify Prints: A Complete Guide to Manual and Mechanical Processes from Woodcut to Ink Jet.* New York: Thames & Hudson, 1986.

Gilpin, William. *An Essay on Prints.* 5th ed. London: by A. Strahan for T. Cadell and W. Davies, 1802.

Globe, Alexander. *Peter Stent, London Printseller circa 1642–1665.* Vancouver: University of British Columbia Press, 1985.

Godfrey, Richard T. *Printmaking in Britain: A General History from its Beginning to the Present Day.* New York: New York University Press, 1978.

————. *Wenceslaus Hollar: a Bohemian Artist in England.* New Haven: Yale University Press, 1994.

Griffiths, Antony. *Print and Print-making; an Introduction to the History and Techniques.* London: British Museum Publications, 1980.

Griffiths, Antony, and Gabriella Kesnerova. *Wenceslaus Hollar, Prints and Drawings: from the Collections of the National Gallery, Prague, and the British Museum, London.* London: British Museum Publications, 1983.

Guinness, Gerald, comp. *St. Paul's Cathedral.* London: Jackdaw Publications, 1969.

Harvey, P. D. A. *The History of Topographical Maps: Symbols, Pictures, and Surveys.* London: Thames & Hudson, 1980.

Haskell, Francis. *History and its Images: Art and the Interpretation of the Past.* New Haven: Yale University Press, 1993.

Hearsey, John E. N. *London and the Great Fire.* London: John Murray, 1965.

122 Hind, Arthur M. *A History of Engraving &
Etching from the 15th Century to the Year
1914.* New York: Dover Publications, 1963.

————. "Studies in English Engraving
V: Wenceslaus Hollar." *The Connoisseur,*
Vol. XCII, No. 386 (October 1933), 215–227.

————. *Wenceslaus Hollar and his Views
of London and Windsor in the Seventeenth
Century.* London: John Lane, The Bodley
Head Limited, 1922.

Holbein, Hans. *The Dance of Death.*
Introduction by Werner L. Gundersheimer.
New York: Dover Publications, 1971.

Howarth, David. *Lord Arundel and his Circle.*
New Haven: Yale University Press, 1985.

Ivins, William M., Jr. *How Prints Look.*
Boston: Beacon Press, 1958.

Jaffé, David. *The Earl and Countess of
Arundel: Renaissance Collectors.* London:
Apollo Magazine Ltd., 1995.

Jessup, Frank W. *Background to the English
Civil War.* London: Pergamon Press, 1966.

Layard, George S. *The Headless Horseman,
Pierre Lombart's Engraving: Charles or

Cromwell?* London: Philip Alan & Co., 1922.

L'Estrange, Roger. *A book of drawing, limn-
ing, washing. . . .* London: by M. Simmons
for Thomas Jenner, 1666.

Levis, H. C. *Descriptive Bibliography of the
Most Important Books in the English Language
Relating to the Art and History of Engraving
and the Collecting of Prints.* London: Ellis,
1912 and 1913. Reprinted 1974.

————, comp. *Extracts from the Diaries
and Correspondence of John Evelyn and
Samuel Pepys.* London: Ellis, 1915.

————. *Notes on the Early British
Engraved Royal Portraits Issued in Various
Series from 1521 to the End of the Eighteenth
Century.* London: The Chiswick Press, 1917.

Levy, F. J. "Henry Peacham and the Art
of Drawing." *Journal of the Warburg and
Courtauld Institutes* 37 (1974), 174–190.

Longstreet, Stephen. *A Treasury of the
World's Great Prints.* New York: Simon &
Schuster, 1961.

Millar, Oliver. *The Age of Charles I: Painting
in England, 1620–1649.* London: The Tate
Gallery, 1972.

————. *Van Dyck in England.* London:
National Portrait Gallery, 1982.

Nevinson, J. L. *The Four Seasons.* London:
The Costume Society, 1979.

Ogden, Henry V. S., and Margaret S.
Ogden. *English Taste in Landscape in the
Seventeenth Century.* Ann Arbor: University
of Michigan Press, 1955.

Orrell, John. *The Quest for Shakespeare's
Globe.* Cambridge: Cambridge University
Press, 1983.

Paper: Art & Technology. Edited by Paulette
Long and Robert Levering. San Francisco:
World Print Council, 1979.

Papermaking Art and Craft. Washington:
Library of Congress, 1968.

Parry, Graham. *Hollar's England: a Mid-
Seventeenth-Century View.* London: Michael
Russell, 1980.

————. *The Trophies of Time: English
Antiquarians of the Seventeenth Century.*
Oxford: Oxford University Press, 1995.

Parthey, Gustav. *Wenzel Hollar.
Beschreibendes Verzeichniss seiner*

Kuppferstiche. Reprint. Amsterdam: Meridian Publishing Co., 1963.

Pennington, Richard. *A Descriptive Catalogue of the Etched Work of Wenceslaus Hollar, 1607–1677.* Cambridge: Cambridge University Press, 1982.

Peterdi, Gabor. *Printmaking: Methods Old and New.* Rev. ed. New York: Macmillan, 1971.

Powell, Anthony. *John Aubrey and His Friends.* London: Eyre & Spottiswoode, 1948.

Praz, Mario. *An Illustrated History of Furnishing.* New York: George Braziller, 1964.

Priestly, Harold. *London: The Years of Change.* New York: Barnes and Noble, Inc., 1966.

Rostenberg, Leona. *English Publishers in the Graphic Arts, 1599–1700.* New York: Burt Franklin, 1963.

Schofield, John. *The Building of London from the Conquest to the Great Fire.* London: British Museum Publications Ltd., in association with the Museum of London, 1984.

Smith, David. *Maps and Plans for the Local Historian and Collector.* London: B. T. Batsford Ltd., 1988.

Springell, Francis C. *Connoisseur and Diplomat: the Earl of Arundel's Embassy to Germany in 1636 as recounted in William Crowne's Diary, the Earl's Letters, and other Contemporary Sources.* London: Maggs Bros. Ltd., 1963.

Stechow, Wolfgang. *Dutch Landscape Painting of the Seventeenth Century.* National Gallery of Art: Kress Foundation Studies in the History of European Art. London: Phaidon Press Ltd., 1966.

Strong, Roy. *Tudor & Jacobean Portraits.* 2 vols. London: Her Majesty's Stationery Office, 1969.

Underdown, David. *Revel, Riot, and Rebellion: Popular Politics and Culture in England, 1603–1660.* Oxford: Clarendon Press, 1985.

Urzidil, Johannes. *Hollar: A Czech Emigré in England.* London: by the "Czechoslovak," 1942.

Van Eerde, Katherine S. *John Ogilby and the Taste of His Times.* Kent, England: Wm. Dawson & Sons, Ltd., 1976.

—————. *Wenceslaus Hollar: Delineator of His Time.* Charlottesville: University Press of Virginia, 1970.

Vertue, George. *A Description of the Works of. . .Wenceslaus Hollar. . .with Some Account of His Life.* London: For William Bathoe, 1759.

—————. *Note Books I. Walpole Society Publications,* XVIII, 1930.

Wheelock, Arthur K., Jr., Susan J. Barnes, Julius S. Held, et. al. *Anthony van Dyck.* New York: Harry N. Abrams, Inc., 1990.

White, Christopher. *English Landscape 1630–1850: Drawings, Prints & Books from the Paul Mellon Collection.* New Haven: Yale Center for British Art, 1977.

Williams, Tamsyn. "'Magnetic Figures': Polemical Prints of the English Revolution." In *Renaissance Bodies: The Human Figure in English Culture, c. 1540–1660,* edited by Lucy Gent and Nigel Llewellyn. London: Reaktion Books, 1990.

Young, Alan R. *Henry Peacham.* Boston: Twayne Publishers, 1979.

Design by Antonio Alcalá
Studio A, Alexandria, Virginia.

Printing by Virginia Lithograph
Arlington, Virginia.

Typeset in Monotype Bembo
Cover printed on Phoeno-Grand
Text printed on Phoeno-Star